DRAWING
Caricatures

DRAWING
Caricatures
HOW TO CREATE SUCCESSFUL CARICATURES IN A RANGE OF STYLES

Martin Pope

CHARTWELL
BOOKS, INC.

DISCARD

About the author

Martin Pope was born in Singapore in 1958 and has lived
in the UK since 1966. Always artistically creative, he started
drawing recognizable caricatures from the age of twelve.
Now he is an established freelance illustrator, receiving
regular commissions from large corporations such as JP
Morgan, Sony and the Royal Bank of Scotland as well as
in-house and national magazines. Drawing caricatures
remains his main love and occupation.

For more information about Martin Pope's work, visit
www.martinpope.co.uk

Picture credits: Corbis 24, 25

This edition printed in 2008 by

CHARTWELL BOOKS, INC.
A Division of **BOOK SALES, INC.**
114 Northfield Avenue
Edison, New Jersey 08837

Copyright © 2008 Arcturus Publishing Limited/Martin Pope
26/27 Bickels Yard, 151–153 Bermondsey Street,
London SE1 3HA

ISBN-13: 978-0-7858-2491-6
ISBN-10: 0-7858-2491-X

Editor: Ella Fern
Design: Adelle Morris

Printed in Singapore

Contents

Introduction

What is a caricature?

The word caricature is derived from the Italian *caricare*, meaning to charge or load. So you could say a caricature is a 'loaded portrait' – one that focuses on a subject's unique facial features and exaggerates them. I believe the essence of a successful caricature is to exaggerate, but not to distort, your subject. Exaggeration is an amplification of the truth, whereas distortion can be misleading, or even incorrect.

Some people believe that the principal aim of caricaturists is to ridicule and insult their subjects, and this was certainly the case in the 18th century and in many cases (particularly in political caricatures) it still is. However, this is just one aspect of caricaturing. Many caricaturists make a living out of producing flattering or entertaining caricatures for novelty gifts, some by creating caricatures of film stars, pop stars and celebrities.

Can anyone learn to caricature?

I believe that more or less everyone can learn to draw and caricature if they really want to. I was fortunate in having natural artistic talent and could draw from an early age, but I certainly wouldn't class myself as musically gifted. I did, on the other hand, manage to teach myself to play guitar to a basic level. Alas, my guitar-playing skills haven't progressed much over the years and I certainly wouldn't earn any money from performing, but I put this down to my lack of commitment, dedication and practice. If I had had a real desire and interest in the subject, I believe I would have progressed onwards and upwards.

Consequently, I'm confident that if you are willing to practise you can learn to draw and to caricature. Note the order in which I used those words 'draw' and 'caricature'. To be able to caricature, you must first master a reasonable level of drawing skill. If you feel you have little drawing ability, I recommend you read a good book on basic drawing skills before attempting the techniques discussed in this book.

Caricaturing could likened to performing as a clown; it might look easy but if you don't learn some basic acrobatics first, you might well

end up with broken bones or at least some serious bruising. While attempting to caricature without drawing skills obviously wouldn't be so catastrophic, it would be very frustrating.

How do caricaturists caricature?

If you asked any caricaturist to describe how they do what they do I think the majority would struggle to give you a decisive answer. This is because most of us learn by trial and error until eventually we master some kind of procedure to work by. Unfortunately it's not easy to say what that is, as we largely do it subconsciously, a little like riding a bicycle. If you want to learn to ride a bicyle there is no substitute for just getting on one and doing it, and likewise with learning to draw caricatures you must just draw, draw and draw. As with any skill, gifted or not you only become good through practice and it doesn't happen overnight. There are however some very fundamental steps that are worth mentioning, so before you drive yourself to despair drawing hundreds of unsuccessful caricatures please read on.

Observation

In a nutshell, the key to caricaturing is observation. Most of us observe faces continuously throughout the day without giving it a second thought. How else would we recognize someone when we meet them or know how to react to facial expressions if we weren't able to process the information we see? To draw caricatures, what we have to do is be aware of the information being received and fast-track it into our conscious rather than let it take the normal route to our subconscious.

The relationship of shapes

Figure 1
Take a look at these five shapes. If you were asked to identify them, you would probably say shape A is a pentagon, shape B a triangle, shape C a circle, shape D an oval, shape E a square and shape F an oblong. Indeed, most people would give those answers unless they had an unusually good eye for measurement.

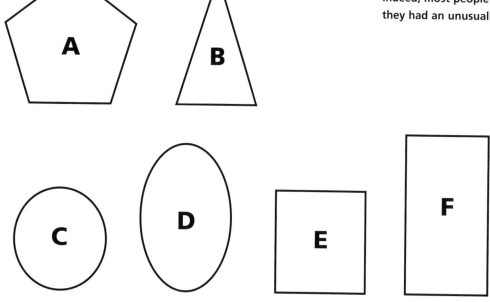

Figure 2

If you take a look at the three shapes shown here, you will notice that the one in the middle stands out from the other two. This is because, unlike the shape either side, it's not a perfect circle but an oval. It's also the same shape that's represented by the letter C on the opposite page.

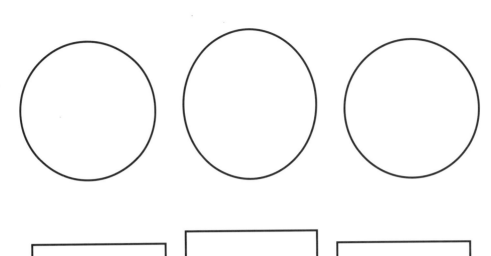

Figure 3

Again the shape in the middle stands out from the other two – it's not a perfect square but an oblong. It's also the shape that's represented by the letter E on the opposite page.

My purpose in showing these shapes is to illustrate that without having a template to use for comparison it is difficult to know if we have our dimensions correct. The whole essence of producing a credible caricature is being able to spot what is different and unique about the face we intend to caricature.

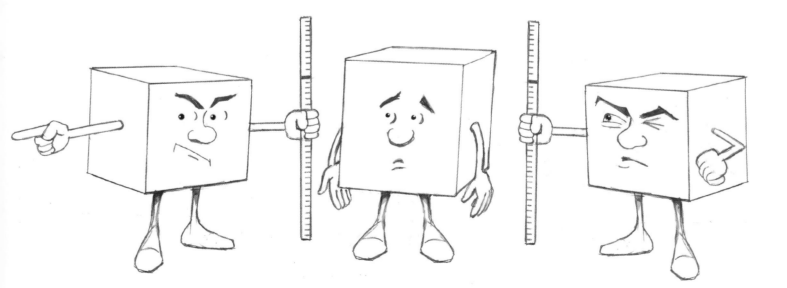

Face recognition

Unlike a lot of the creatures on this planet, we human beings have facial characteristics quite different from one another and fortunately for us we also possess the ability to recognize these features after they are subconsciously stored in our memory.

When you stop to think about it, it's an amazing accomplishment that our minds are able to record the precise layout of an individual's features so that when we next see them we can identify them out of the hundreds or maybe even thousands of faces that we have in our memory bank. More amazing still is that if we come across the same face some 20 years later we may recognize it, even though the subject's hair may have gone grey, receded or disappeared altogether. They may also have lost or gained weight and acquired an extra chin or two and they will certainly have developed some wrinkles, but, with a little effort, we can usually identify them purely by recalling the layout of their eyes, nose and mouth.

Just how we manage to accomplish this I'm not entirely sure. However, for the purpose of drawing caricatures all you need to know is that most of us possess this incredible ability. The next step is to fine-tune this natural gift and take more notice of it.

To be able to caricature successfully you must develop your capacity for face recognition further in order to identify what is unique about each face you draw. Step by step throughout this book you will discover how to identify what makes people's facial features individual in size, shape and layout, so that you can then exaggerate them effectively.

Take a look at the faces displayed on these two pages. Look at each one individually for about 10 seconds. If you were shown them again you would probably know you had seen them before, which means you have subconsciously stored the relevant information to be able to recognize them. The key is accessing this information and getting it down on paper.

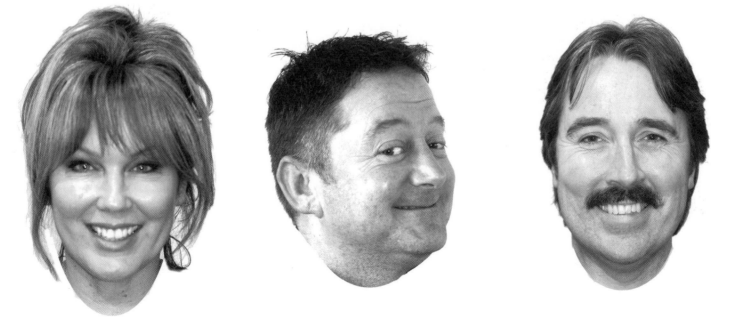

The Face Base

Once you have consciously taken notice of the information you have gained about someone's face so that you can transfer it on to paper, the next step is to establish what's different about the information in comparison to that of another face. At this stage it's important that the face you compare it to has an average set of features with an average face layout. To help provide you with a guideline to work from I have created a face that is a mixture of everyone. It represents no particular race, nor is it male or female – it's an invention and it's pretty nondescript, which is perfect for what we need. It is only right we should put a name to a face, so let's call this 'the Face Base'. The Face Base would be a caricaturist's nightmare, as it has very little character.

For example, if you were asked the following five questions about the Face Base:

- What sort of a mouth does it have?
- What sort of nose?
- What sort of eyes?
- What sort of chin?
- What sort of ears?

Your answers to all five would most probably be either 'just normal' or 'average' – not very useful if you were an eye witness describing the prime suspect of a crime.

If, on the other hand, you were asked to describe the face shown on the right it would be a lot easier:

• What sort of a mouth does he have? *Small and down-turned.*
• What sort of nose? *Long, wide and pointed.*
• What sort of eyes? *Set close together, one slightly higher than the other.*
• What sort of a chin? *Small.*
• What sort of ears? *Large and sticking-out.*

As you can see, with this face there is a lot more to work with. It has character.

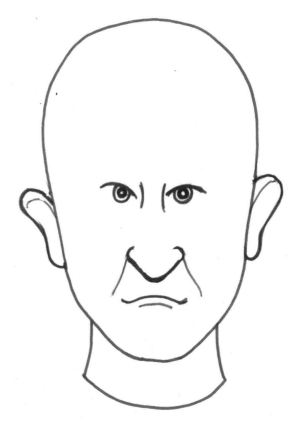

Even with the addition of eyebrows, cheek bones and some shading (below), the Face Base would still be hard to describe. But although it is lacking in facial character it serves as a valuable point of reference to work from.

Proportions of the head

Full face

These two lines measure the width between the eyes. This is the same measurement as the width of one eye. The width across the nostrils is also the same distance.

The distance between the outside of the eye to the side of the head is also approximately the same as the width of one eye.

This line divides the head in half horizontally. Notice that the top of the eyes and ears are positioned higher than the line.

The top of the nose, eyes and ears are in line with each other.

The measurement from this line at the base of the nose to the bottom of the chin accounts for about 30 per cent of the overall head height. The bottom of the ears is also on the same line.

These two lines coming down from the centre of the pupils of the eye are close to the width of the mouth.

Profile

This line illustrates where the back of the head finishes in relation to the square. As you can see, it falls just short of filling 95 per cent of it. However, because the difference is so small, it's still worth using a square as a guideline; just remember to draw the head slightly within it.

This line divides the square in half vertically. You can see the front part of the head to the right of the ear lobe comfortably fills 50 per cent of the square. The ear starts from the centre, positioned to the left side of the square.

This line divides the head in half horizontally and, as with the full-face illustration, the line runs just below the eye.

The top of the eyes and ears are in line with each other.

The base of the nose and ears are more or less in line with each other.

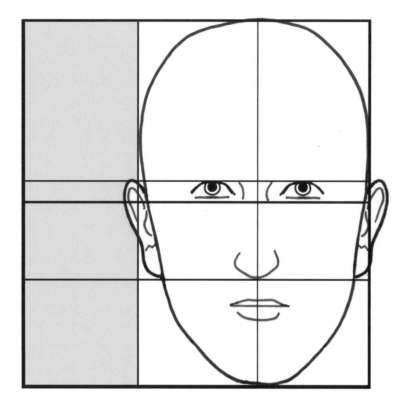

Full face

When viewing the Face Base from the front, notice how much narrower it is compared to the profile on the opposite page; it takes up only about 70 per cent of a square.

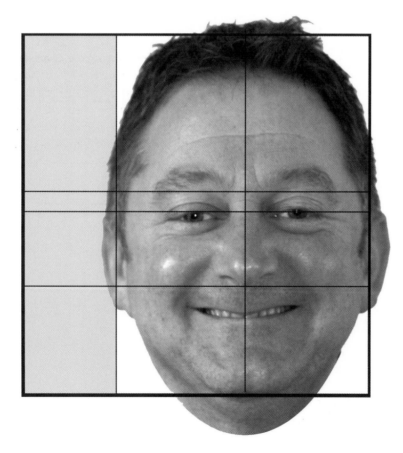

Here the head of one of our subjects is placed within the Face Base square so that the top of his head meets the top of the square and his chin touches the base. You can see that in relationship to the height of his head, his head is wider than that of the Face Base.

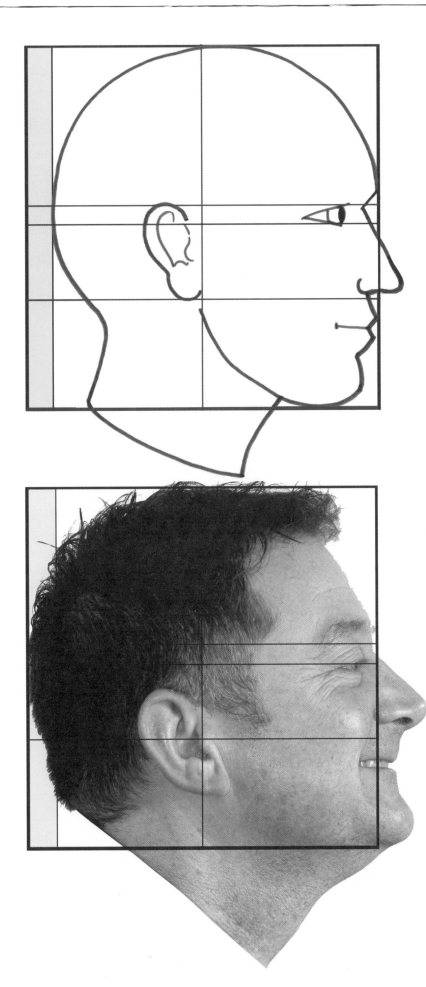

Profile

Viewing the Face Base head from the side, it's immediately apparent that the width is a lot greater than in the full-face illustration. Instead of only filling 70 per cent of a square it very nearly fills it completely. If the nose were included it probably would fill it, but here we are focusing on the dimensions and structure of the head itself.

By using the square as a comparison guide it can be seen that unlike the Face Base, our subject's mouth and chin jut right outside the square. Throughout the book, this square with guidelines will be used for comparing different head shapes.

Layout of facial features

Before analyzing the size and shape of an individual's features we must first observe the face map – the layout of the features.

Take a close look at the nine faces opposite. Although they all have features that are identical in size and proportion, none of them resemble each other. This is because the way their features are placed is different in every face, in some cases quite considerably so.

The eyes, nose and mouth on faces 2 and 3 have exactly the same layout as the Face Base (1). The only difference is where they are positioned on the head. Face 2 is a copy of the Face Base except that all the features are positioned lower down on the head. This gives a more feminine or child-like look, with a smaller chin and larger forehead. Face 3 is again a copy of the Face Base except that here the features are higher up on the head, giving a more masculine look, with a larger chin. Face 4 also looks adult and masculine, with the features widely spaced down the length of the head.

With faces 4, 5 and 6, the main difference is the position of the mouth in relation to the other features. Faces 4 and 6 appear long because the mouth is positioned low down, whereas face 5 does not because the mouth is close to the nose.

The only difference faces 7, 8 and 9 have from the Face Base is their eyes. Face 7 has the eyes positioned wider apart than normal. Face 8 has the eyes slanted upward, giving an oriental look, and in face 9 the eyes are closer together.

Observing them closely, you can see that all nine faces have the same expression, though this doesn't appear so at first. Face 6 looks somewhat miserable, while face 4 looks stern. Face 3 seems maybe a little arrogant and face 1, the Face Base, is pretty nondescript, as you would expect.

So what can be learned from this, apart from the fact that some unfortunate people can't help looking miserable? It's that our face layout, no matter how small the difference may be from one person to another, gives us individual character. This is a very basic but important part of understanding how to see and record what is individual about the subject you want to caricature.

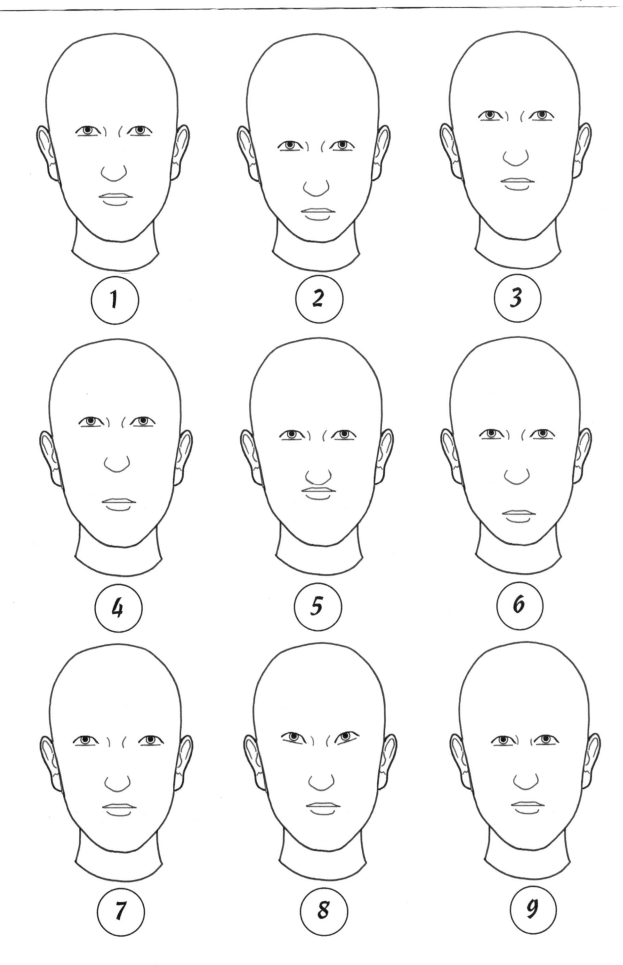

Profile comparisons to the Face Base

Make a point of viewing any subject you decide to caricature from the side. There is valuable information to be gained from looking at them from this angle.

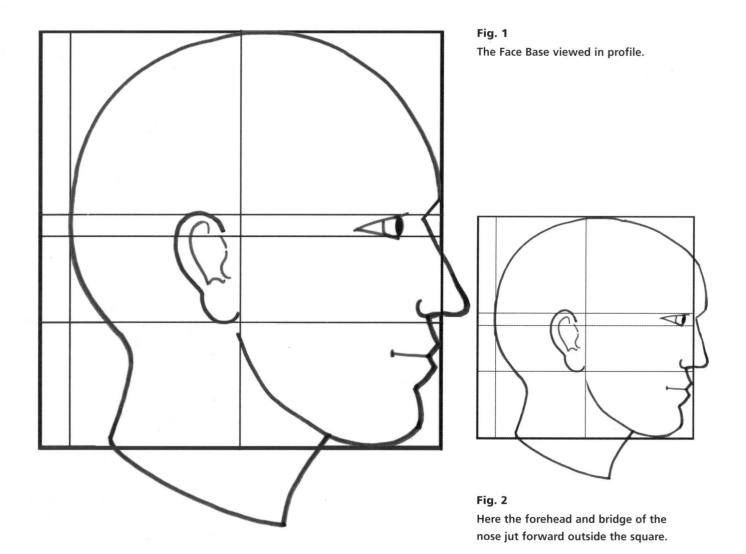

Fig. 1
The Face Base viewed in profile.

Fig. 2
Here the forehead and bridge of the nose jut forward outside the square.

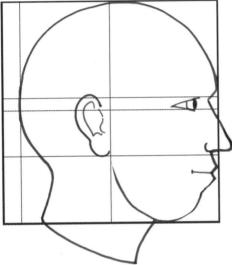

Fig. 3

This subject's small chin almost disappears into the neck.

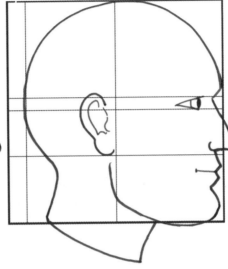

Fig. 4

A large, strong jawline such as this would belong to an adult male.

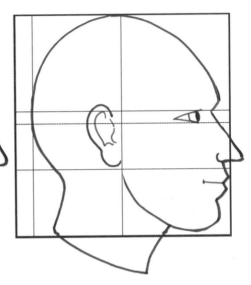
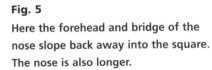

Fig. 5

Here the forehead and bridge of the nose slope back away into the square. The nose is also longer.

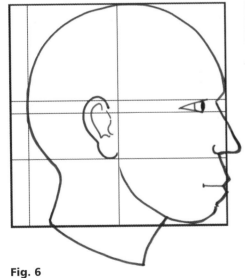

Fig. 6

In this profile the gap between the nose and the mouth is larger and the chin is smaller.

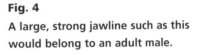

Fig. 7

From the bridge of the nose the whole face slopes down and inwards.

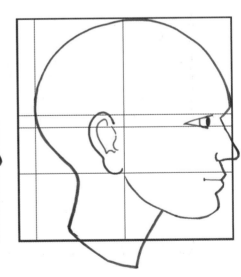
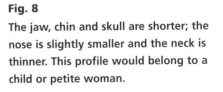

Fig. 8

The jaw, chin and skull are shorter; the nose is slightly smaller and the neck is thinner. This profile would belong to a child or petite woman.

Study the differences

This time we are looking not just at the face layout but also at the size and shape of individual features and of the head itself.

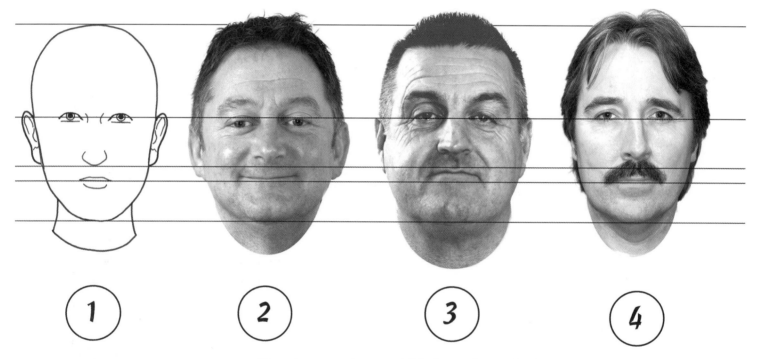

① ② ③ ④

Here there are three real-life faces alongside the Face Base. All four heads fit between two horizontal lines across the top of the head and the base of the chin. There are also lines running through face **1**'s pupils, beneath the nose and through the middle of the mouth. As you can see, the position of the features on each face differs considerably. The eyes of face **2** drop below the line, on face **3** they are dead centre and on face **4** they are above it. In the case of the nose, on face **2** it's slightly above, on face **3** considerably above and face **4** in between the two. The mouth of face **2** is almost dead centre, on face **3** it is high and on face **4** it is almost centred again.

Now we have established what's different about their face layout from a horizontal viewpoint, let's take a closer look at their individual facial features from the same viewpoint.

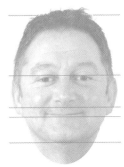

Face 2

This is a broader face than 1, with a much shorter nose. The ears drop far lower down in line with the mouth.

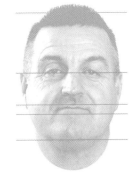

Face 3

Again this is a broader face than 1, with a very short nose. The ears are lower down and the chin is large.

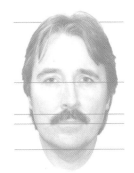

Face 4

The head shape is similar to 1, but while the nose looks shorter it is not – remember the eyes are positioned higher, therefore the bridge of the nose is higher. If the eyes were in line with face 1, the nose would be about the same size, but it's bent over to one side.

SEE WHAT YOU WANT TO SEE

To be able to record someone's face pattern you need to simplify what you are looking at. Practise seeing face patterns and try not to be distracted by the hairstyle, eye colour, skin tone and so on. All these things will be included later, but at this point see only the information that you need to and disregard the rest.

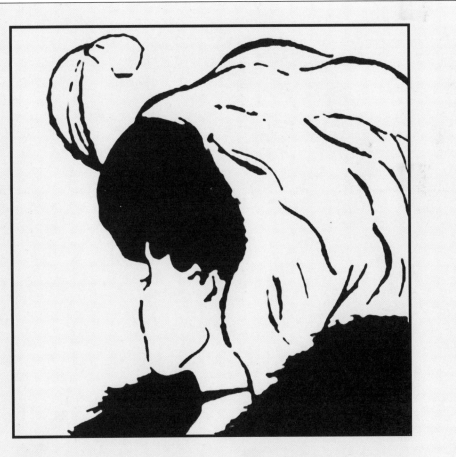

This is an example of how you can see two separate images within the same space. Do you see the old woman or the young one, or both? While this isn't a caricature it makes the point that you can train your eye to see what you want to. The same goes for the face – train your eye to understand the layout first.

Asymmetrical faces

The layout of our facial features can be quite different from one side of the face to the other – in fact it is quite rare that they are anywhere close to being symmetrical. To illustrate my point further take a look at the photograph below. At first glance this man does not look odd or unusual. It is only when we start studying the face in more detail that we begin to notice what unique characteristics he has. As a caricaturist this is what you must train your mind to do. Notice things that the average person does not.

In fact, this man's face is far from symmetrical. Notice his right eye is quite different to his left. The eyelid of the left eye (as we see it on the page) droops downward, whereas his right eye appears more wide open. The left nostril is set slightly higher than the right.

The differences between one side and the other become even more apparent when we show them as mirror images. Take a look at the two photographs on the opposite page.

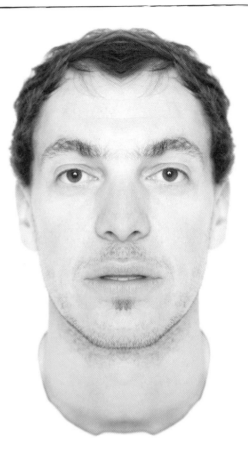

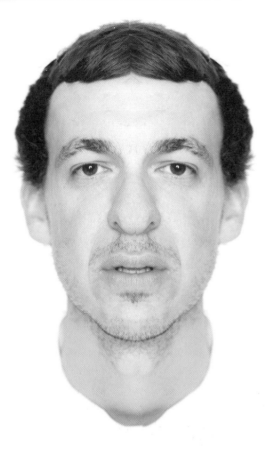

The right side of this photograph is a mirror-image copy of the left, making the face entirely symmetrical. Note how different the man looks when compared to the original photograph. His hairline is centred and his eyebrows both slightly raised.

This is the other side of the face shown as a symmetrical mirror image. The nose is bulbous compared to the image on the left and the jaw is much narrower. They look like two completely different people.

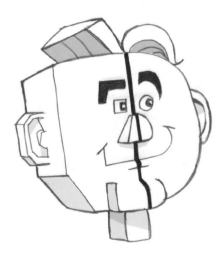

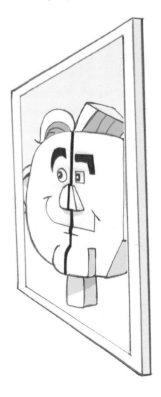

The features in detail

EYES

Capturing a recognizable likeness of your subject's eyes plays a very important part in creating a good caricature. In this context, 'eyes' also refers to the flesh and muscles that surround the eye itself together with the eyebrows and eyelashes.

We can learn a great deal about someone by looking at their eyes. We can tell if they are happy, sad, excited, angry, surprised, frightened and so on, and get a rough idea how old they are.

Young children, for example, appear to have larger eyes than adults. This is not true, of course – it's just because their heads haven't finished growing, so their eyes take up a larger percentage of their face than an adult's do.

In an infant, the skin around the eyes is smooth, with few or no wrinkles. However, as we grow older folds start to form in the skin all around the eyes. Laughter lines, crow's feet, bags, call them what you will, everyone gets wrinkles eventually.

Also, the iris (the coloured part of the eye around the pupil) starts to merge into the white of the eye as we grow older. It looks less sharp and clear than that of a younger person's iris, which has a definite contrast against the white of the eye.

When drawing the eyes it's important to remember they are in fact eyeballs, spherical in shape. Of course, a good percentage of the overall shape is hidden behind the lids and the flesh below the eye.

If you are drawing eyes looking up, down or to the side, keep in mind that because they are spherical the iris and pupil will appear oval rather than circular.

When viewing the eye face on, the iris and pupil look circular.

If your subject has light-coloured eyes the pupils will stand out more in contrast to the iris.

The size of the pupils is affected by lighting conditions; in low light they increase in size and vice versa. The size is also affected by your subject's emotional state.

In most people, the eyes are synchronized in movement and positioning. If you draw them out of synchronization it will give an odd appearance and not resemble your subject very well at all. If, on the other hand, they have one eye slightly higher than the other, exaggerate the amount.

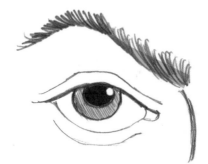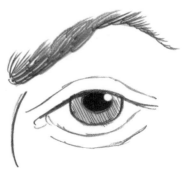

Eyes in synchronization

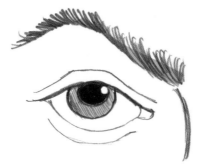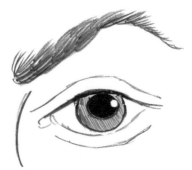

Eyes out of synchronization

Men usually have thicker eyebrows than women and sparser eyelashes. Women often pluck their eyebrows and apply mascara to their lashes.

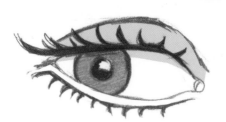

When drawing women's eyes, note if they are wearing make-up and how much, as this can affect their appearance considerably.

Expressive eyes

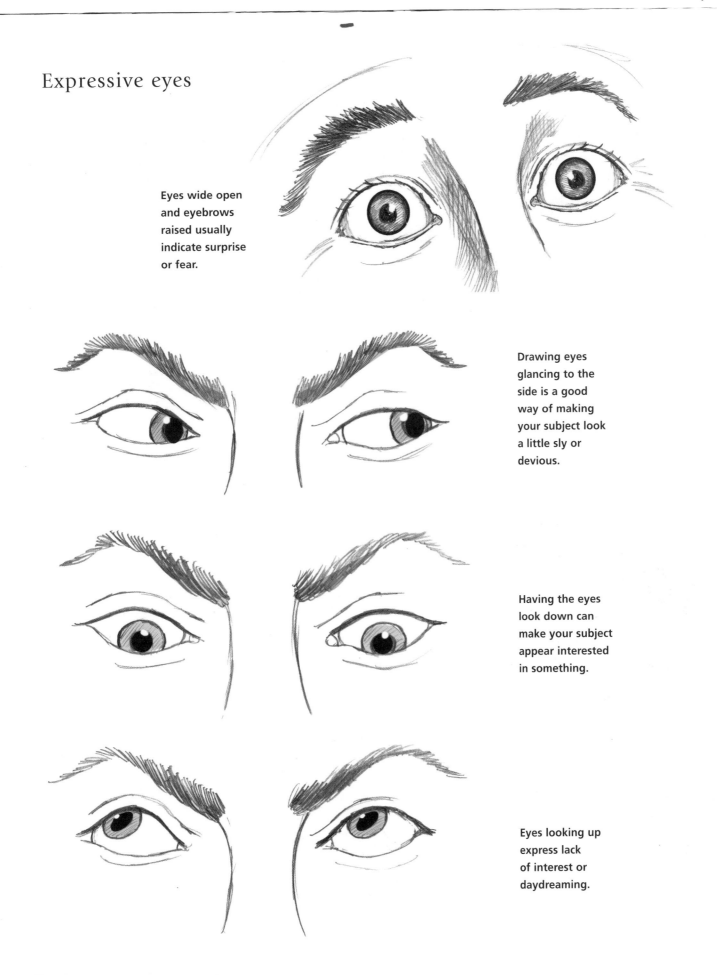

Eyes wide open and eyebrows raised usually indicate surprise or fear.

Drawing eyes glancing to the side is a good way of making your subject look a little sly or devious.

Having the eyes look down can make your subject appear interested in something.

Eyes looking up express lack of interest or daydreaming.

Famous eyes caricatured

These eyes are from my Arnold Schwarzenegger caricature (see page 45). He has a distinct deep brow and thick eyebrows.

There's no mistaking Mr Bean's eyes. They are deep-set, so plenty of shading is needed around the top of the eye. We identify him with thick, long, raised eyebrows and large, wide-open eyes.

I haven't drawn a Clint Eastwood caricature, but if I did, the eyes would look like this – just narrow slits and plenty of wrinkles.

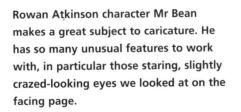

Rowan Atkinson character Mr Bean makes a great subject to caricature. He has so many unusual features to work with, in particular those staring, slightly crazed-looking eyes we looked at on the facing page.

Pope

NOSES

The nose is very often one of the most prominent features of the face and, dependent on its size and shape, could well be the main facial feature the caricaturist will choose to exaggerate.

There are certainly a vast selection of noses out there – hooked, upturned, bent, bulbous, snub, Roman, and so on. It's certainly worth paying a lot of attention to getting this part of the caricature right. Study the feature, find out what is unique about it, then exaggerate it.

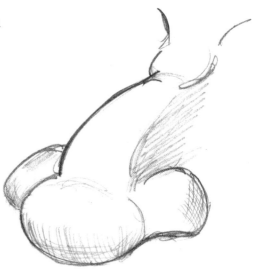

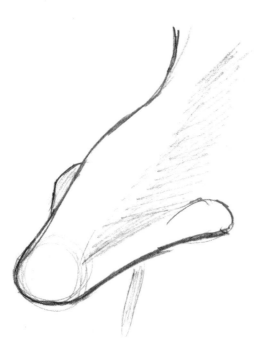

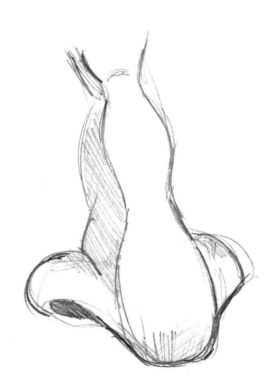

If the nose turns up, turn it up some more; if the nostrils flare out more than average, flare them out further.

Don't just exaggerate the size of the nose for the fun of it. Some caricaturists stretch the size of the nose whoever they are drawing as a matter of course. If you do this, you run the risk of creating the reverse effect of what you are trying to achieve – a recognizable caricature of someone.

If the nose is average or small, leave it that way, and exaggerate some other features that warrant it. This way you will maintain a good likeness and create a great caricature.

You could take your pick with Prince Charles as to which of his features are the most prominent. His nose, ears and mouth are all quite large and unusual, although here I have chosen to exaggerate his nose in particular. A superb subject to caricature.

MOUTHS

The mouth is another prominent facial feature and can be the most complicated to draw because its size and shape can alter considerably from a small puckered kiss to a big, wide-open, hearty laugh exposing most of the teeth.

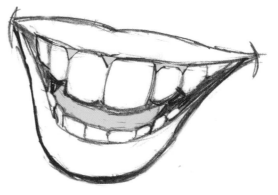

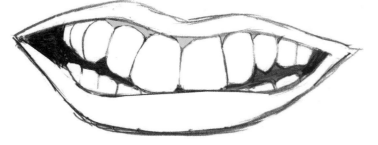

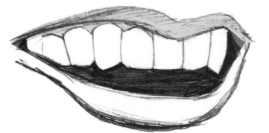

All of the 32 teeth can look very different from one another in shape, size and position.

Some grow crooked, out of line with the rest. Some grow outward, others inward.

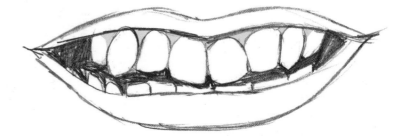

Sometimes teeth grow apart, leaving gaps between them. Anything that is unique is worth exaggerating.

When people smile the amount of gum on display is also an individual characteristic worth taking note of. Some have small teeth with a lot of gum showing, while others have big teeth with very little gum to be seen.

Here is an example of a set of teeth and lips caricatured to the extreme.

LIPS

The lips can vary in size and shape from one person to another by a considerable amount. Women tend to have fuller lips than men but this is not always so.

Some people have very thin lips, hardy noticeable at all. Others have large, voluptuous lips.

The bottom lip is generally thicker than the top lip and has a more curved appearance. The top lip has a more flat and chiselled look.

It's believed that the fuller women's lips are, the more attractive they are to men, so women tend to wear lipstick to enhance their shape.

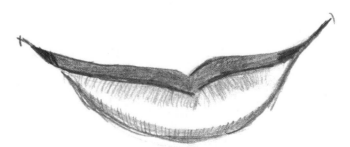

Tina Turner has a some great facial features to work with. The high cheekbones, the flared nostrils and above all a large mouth, with full lips and bright white teeth.

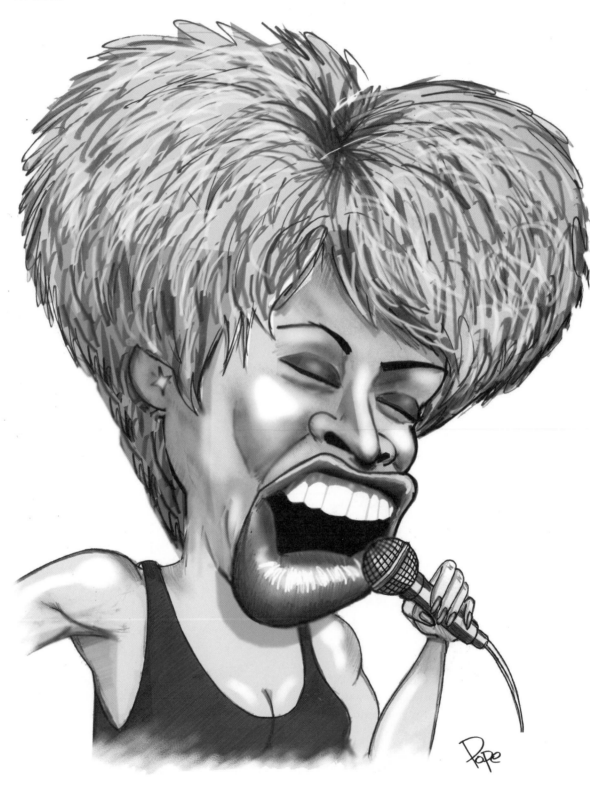

EARS

These flesh-covered cartilage appendages on either side of our head can vary quite considerably in size and shape. Take a look at the selection here.

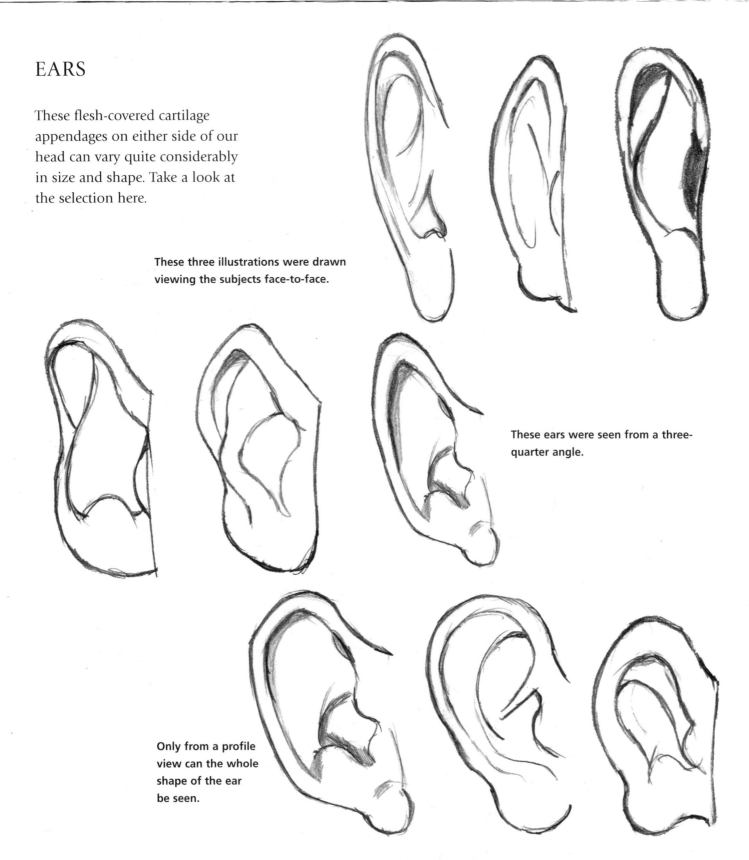

These three illustrations were drawn viewing the subjects face-to-face.

These ears were seen from a three-quarter angle.

Only from a profile view can the whole shape of the ear be seen.

Depending on how large the ears are in comparison to the rest of the subject's features, they can sometimes be the main facial feature a caricaturist will focus on.

The three faces on this page are identical in layout and size apart from their ears. Each one has a different pair.

This one to the right has short, stubby, sticking-out ears.

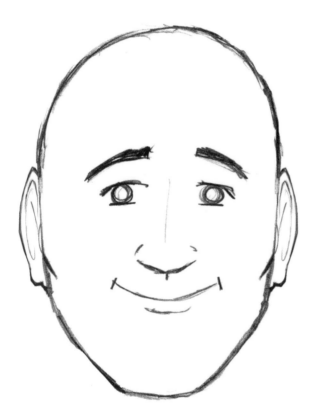

The ears on this illustration are long and lie almost flush to the side of the head, hardly protruding at all. Notice how the head on this illustration looks thinner than the other two. It's not – it just appears that way because of the ears.

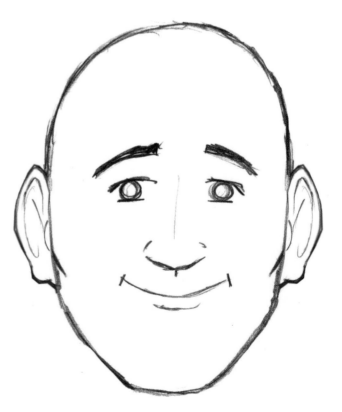

This illustration, like the one at the top, has ears that protrude and they are also quite long. Because of the overall percentage of area they cover, the head appears to be shorter and wider than the others. This illustrates how significant the ears are and why it's worth paying particular attention to their size, shape and positioning relative to the rest of the facial features.

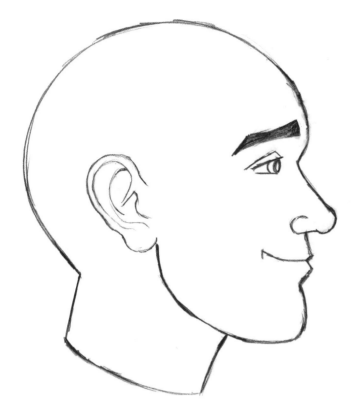

These three illustrations are also identical apart from the ears. However, as we are now viewing them in profile, we can see only one ear and we can't see how far it protrudes from the head.

It's obvious that the ears here are all different in size, shape and position. However, this doesn't drastically alter the overall appearance of our subjects as it did on the opposite page when viewing them face-to-face.

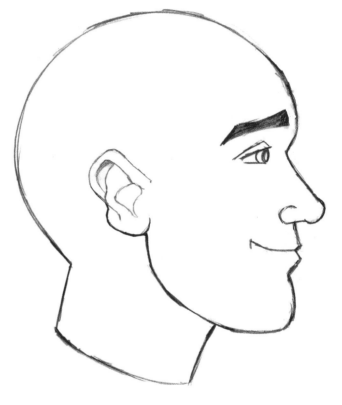

This one looks a little unusual as he has large, pointed, pixie-like ears. Even so his overall look is not that different from the other two.

If your subject has large or unusual ears, choose either full-face or a three-quarter view to draw them from. This way you can take the opportunity to exaggerate their uniqueness.

Jaw lines, chins and necks

JAW LINES

All of the drawings below have nose, mouth and ears of similar layout and proportion. However, the shapes and sizes of the jaw lines are different. As you can see, the jaw line has a significant effect on the overall appearance of a face.

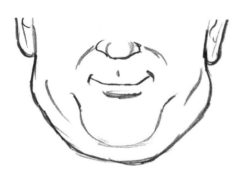

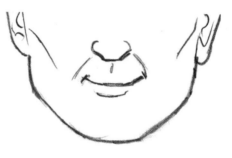

These two faces have more or less the same jaw line. However, because of the extra flesh around the neck on the one on the left, the jaw line isn't visible.

These thick, strong, angular jaw lines are more common in men than women. However, some women do have strong, angular jaw lines and still look feminine.

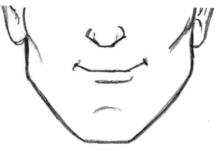

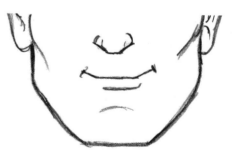

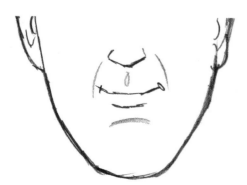

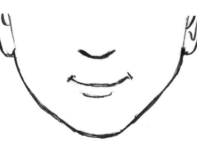

These two jaw lines are in complete contrast to one another. The one on the right is more likely to be that of a female or young child, while the one on the left is probably that of an adult male.

Jaw lines, chins and necks in profile

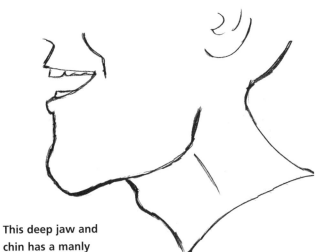

When you are drawing a man, note that the Adam's apple is usually visible.

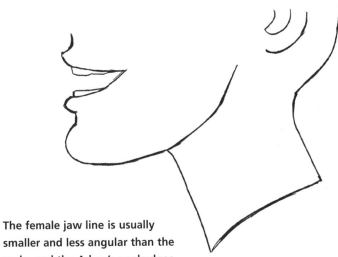

The chin and jaw line are the same on both these illustrations. One looks lean and pointed, while the other looks less prominent because of the extra flesh around the neck.

This deep jaw and chin has a manly appearance.

The female jaw line is usually smaller and less angular than the male, and the Adam's apple does not show.

In relation to the rest of the head, young children usually have a very small jaw line and chin which will grow considerably as they reach adulthood.

Jaw lines, chins and necks in full-face and three-quarter view

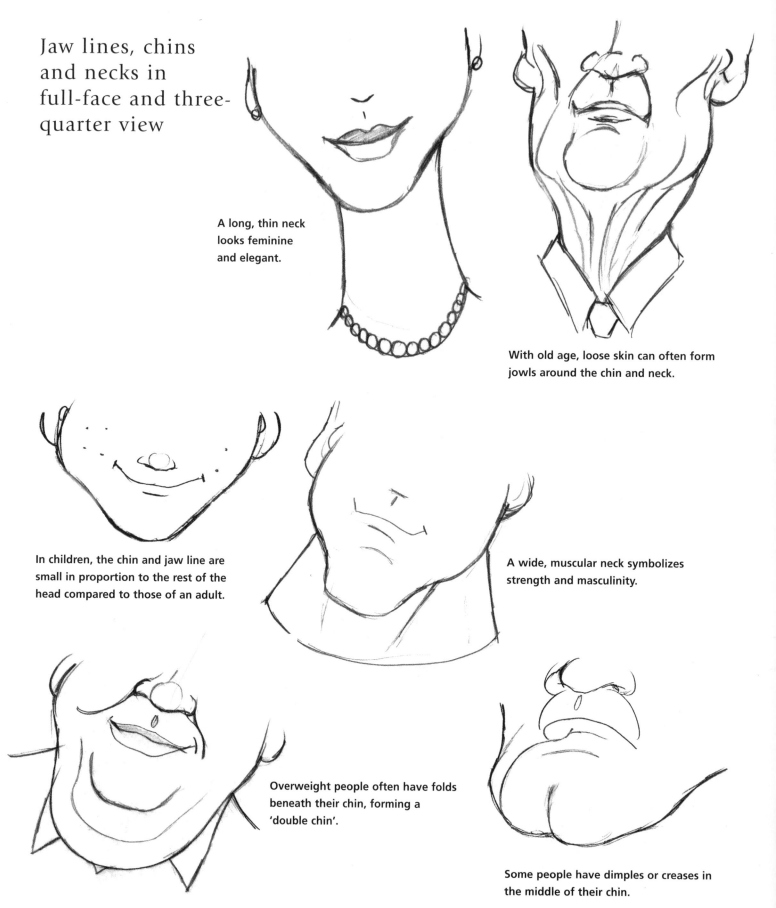

A long, thin neck looks feminine and elegant.

With old age, loose skin can often form jowls around the chin and neck.

In children, the chin and jaw line are small in proportion to the rest of the head compared to those of an adult.

A wide, muscular neck symbolizes strength and masculinity.

Overweight people often have folds beneath their chin, forming a 'double chin'.

Some people have dimples or creases in the middle of their chin.

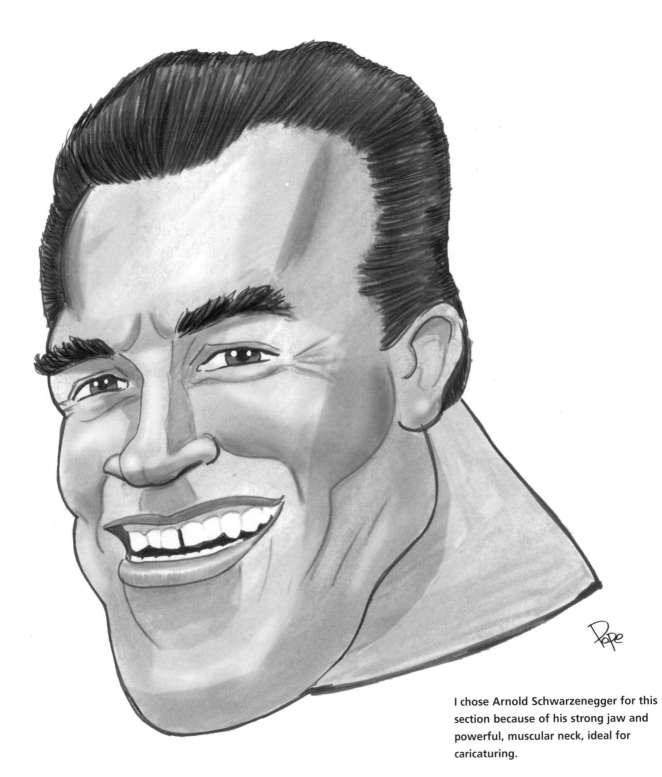

I chose Arnold Schwarzenegger for this
section because of his strong jaw and
powerful, muscular neck, ideal for
caricaturing.

Hairstyles and facial hair

The type of hair someone has and, more particularly, the way it is styled can influence their appearance considerably, as it can make a face appear older, younger, wider, thinner, longer or shorter. A hairstyle can also be very much like clothing in that it makes a statement. The nine images below are identical in everything other than the hair.

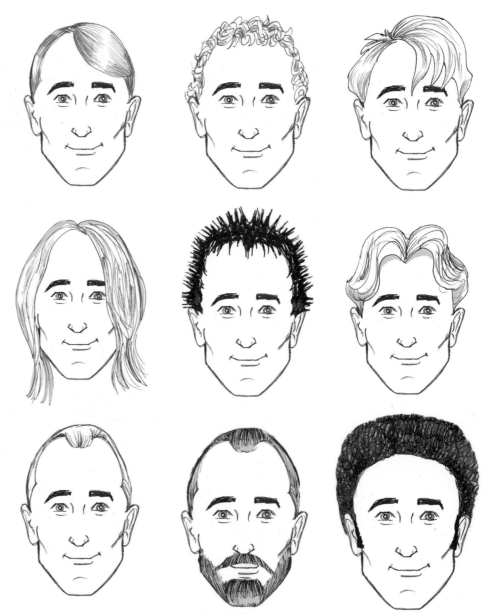

If the hairstyle is particularly unusual in any respect it could end up being one of the main features of your caricature. Remember that you are looking for anything that makes your subject different – when you identify what it is, exaggerate it.

In a caricature of a woman it's not unusual for a large percentage of the artwork to be hair. Bear in mind that hair as a whole consists of a mass of tiny individual strands that, when short, often stick up and when longer hang down. Most hair will have been cut in layers that overlap, adding more style and shape, and the way to make this look realistic is to add shading where one section of hair lies over another. Add some fine lines, too, to give the impression of individual strands.

Unless your subject's hair is jet black it will usually consist of various shades of similar colour. Light reflects off the hair, especially if it's dark and shiny, so leave some gaps in the relevant areas when adding the darker shades.

To give the appearance of light reflecting from the hair, leave gaps in the darker shades.

When you are caricaturing women, the hair alone will often take up 50 per cent or more of the drawing.

Hairlines vary from one person to another and are especially important when you are drawing men. Generally speaking, as men grow older their hair tends to recede, to the extent that they may become completely bald. The hairline makes a big difference to the overall appearance of your subject's face, so make sure you give it plenty of attention.

Facial hair such as beards and moustaches can completely transform someone's appearance and they can be a focal point of your caricature. For extra realism, add some tone to the shaved area of a man's face.

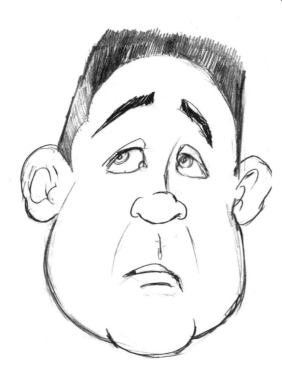

Although Scottish comedian and actor
Billy Connolly has plenty of facial
character, his long, wild hair and goatee
beard certainly add to his comical image.

Facial expressions

By looking at the expression on someone's face we can usually tell if they are happy, sad, excited, scared, aroused and so on. As a caricaturist, your aim should be to identify the expression that is typical of your subject and then exaggerate it.

All the illustrations in this section are drawn without hair so that the focus is purely on the facial expressions.

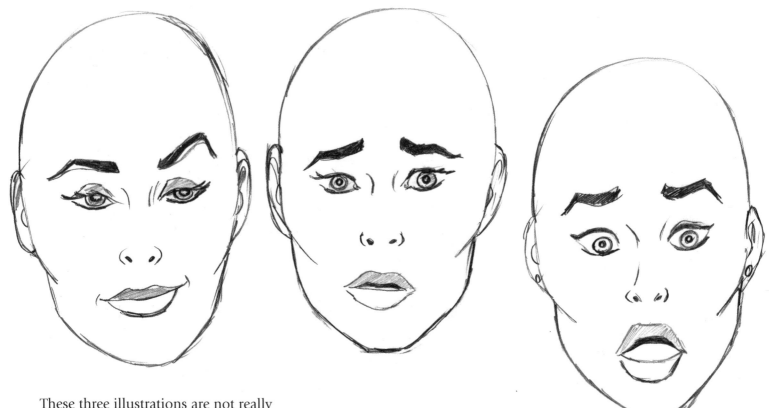

These three illustrations are not really caricatures – they are more in comic book style. However, before exploring the exaggeration of expressions for caricature I wanted to illustrate how these three faces show completely different emotions without any distortion for emphasis.

The eyes and eyebrows play a big part in the type of expression being displayed. With one eyebrow raised and eyelids lowered, the face on the left looks smug and all-knowing. The face in the centre, with eyebrows drawn together, looks worried. When the eyes are wide open and the eyebrows raised as in the face on the right, it usually means the subject is shocked, surprised or frightened.

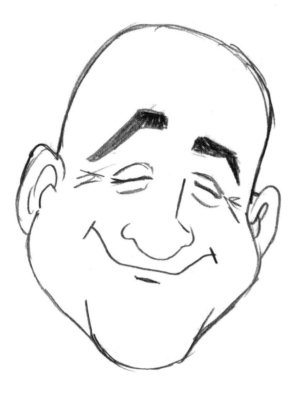

To illustrate the point about the eyes and eyebrows further, the three faces on this page are identical apart from their mouths.

In this illustration the subject has a big grin and is obviously finding something very amusing.

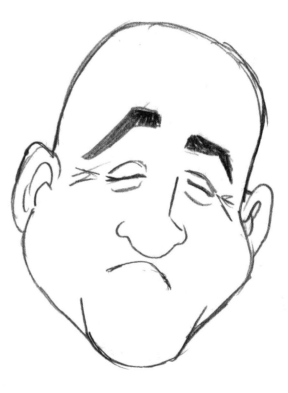

This subject has a down-turned mouth, which would usually indicate unhappiness. However, because of the way the eyes and eyebrows are positioned, the subject looks as if he could be trying not to laugh, or is just about to.

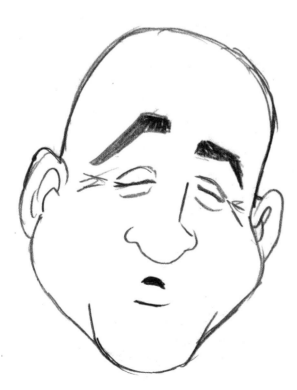

The mouth in this illustration usually signifies shock. However, again because of the position of the subject's eyes and eyebrows, he could be expressing joy, catching his breath in between laughter, or about to sneeze.

When I was a child I would doodle on my exercise books in class and as an adult, even before I became a professional artist, I would doodle while I was on the phone. Doodling – drawing freely with no definite purpose – is a great way of exploring expressions and movement. Just experiment – think happy draw happy, think sad draw sad – and you'll be surprised what you come up with. The faces and expressions illustrated on these two pages weren't supposed to resemble anyone in particular; they were drawn as doodles while I was thinking of various emotions.

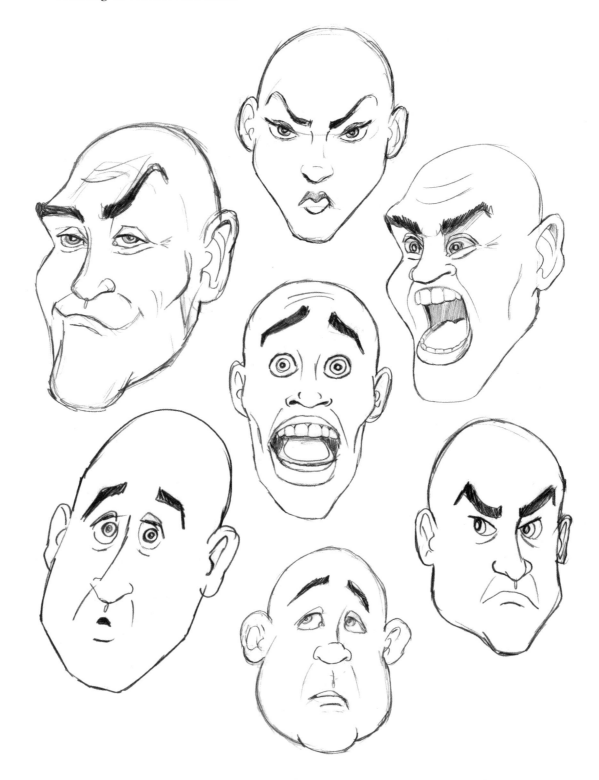

A good way of studying expressions is to sit in front of a mirror and draw your own. Try to feel various emotions and make some quick sketches as you do so. Another thing you can do is take some digital photos of yourself or some other willing party pulling various expressions. You can then download them to a computer and save them on file for future reference.

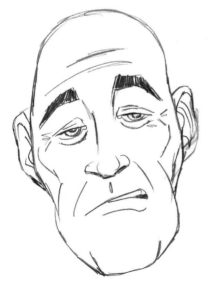

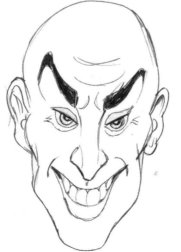

Choosing the right expression

Facial expressions play a significant part in identifying an individual's character, so as a caricaturist it's very important that you recognize the expressions that best represent the subject you are drawing. I'm sure you have at some time seen a photograph of yourself that you thought looked nothing like you. The camera probably caught you in a split second between one expression and another, therefore capturing a look that isn't familiar to you or anyone who knows you. Expression is just as important as features in making a drawing recognizably like the subject.

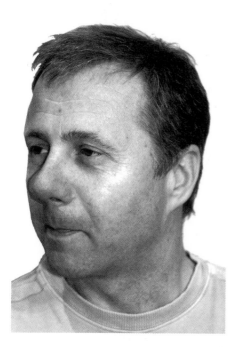

This photograph is a great example of a 'mid-expression moment', taken between one expression and another. It gives the impression that the subject has a long face, droopy eyes and a small, downturned mouth, none of which is true.

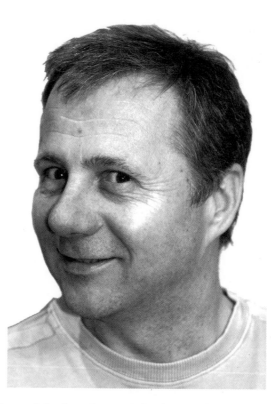

Notice how the shape of the face changes when our subject smiles. His mouth stretches wider and rises at each end. His cheek muscles also rise and become more pronounced, giving the impression of a slightly wider face with high cheekbones. This action also forces the flesh below and to the side of the eyes to scrunch up, covering the bottom part of the eyes slightly. In most people, the eyes generally open wider at the top when they smile, giving a more surprised, alert look. The eyebrows usually rise slightly and wrinkles become more defined on the forehead.

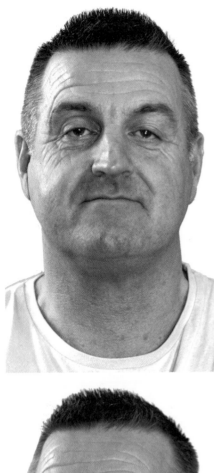

The photograph shown left lacks expression – it would be perfect to use as a passport photograph but not at all suitable as a reference for a caricature.

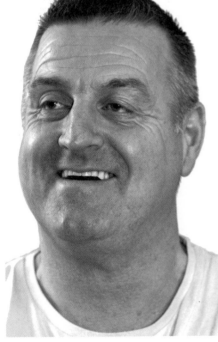

This photograph is far more suitable for a caricature. The subject is showing his teeth in a smile, which is a bonus as they are one of his unique features. The angle this photograph was taken from is also an advantage as we can now get a better view of his nose and chin.

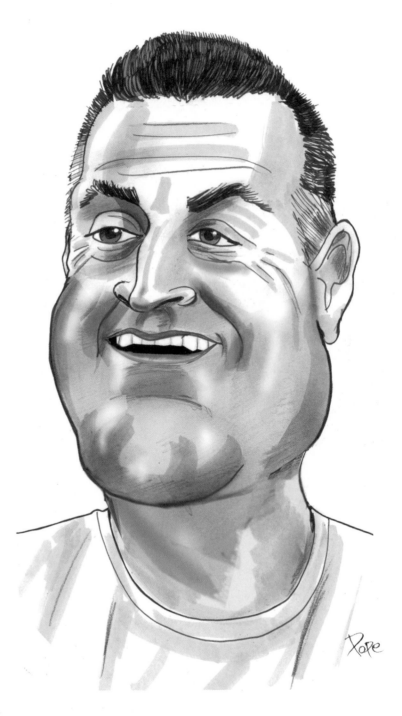

As a result of choosing the right expression, the finished caricature is lively and fun.

Caricaturing an expression from memory

It always pays to acquire good reference photos to work from, but it's not always feasible. If the individual you wish to caricature displays unique facial expressions it may be possible to capture one of them from memory alone. To demonstrate my point I worked here from a photograph of the movie star Jack Nicholson which didn't capture him with his most charismatic and characteristic look.

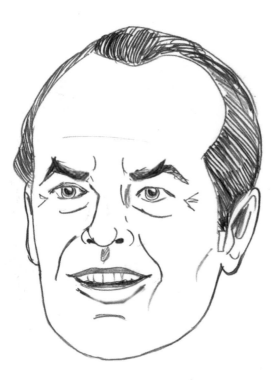

Fig. 1

This is a basic line drawing traced from the photograph – something I don't normally do, but it was useful for the purpose of this exercise. It doesn't look much like Jack at all, yet all the features are in the right proportion and in the right places. Needless to say, I didn't use this drawing as a guide to capturing Jack's character, only as a very rough guide for layout. Jack has such a strong screen presence that I found it quite easy to picture in my mind the facial expression I wanted to capture. The next three images illustrate the stages I went through in caricaturing the expression I wanted.

Fig. 2

Here Jack's eyebrows have been raised high and increased in length slightly; they also curve inwards. The height of the hairline has been exaggerated to make the forehead larger by comparison with the rest of his face and I've given him less hair so that the hairline looks more defined. The mouth has changed to accord with how I remember Jack looked as the Joker in the 1989 film *Batman*. His nose isn't large compared to the rest of his features so I decided to reduce it further. Remember that exaggeration doesn't necessarily mean making something larger – it can equally apply to making it smaller.

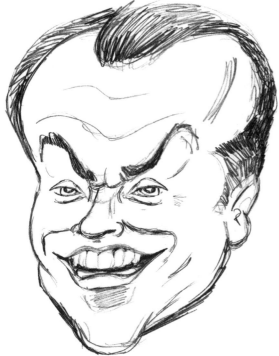

Fig. 3

Now I have made the mouth larger, forcing the cheekbones up higher. The nose has been reduced a little bit more and I have taken the eyebrows up even further. I have also increased the size of the forehead slightly. A small but very significant change has been made to the eyes; I've drawn the eyelids half-closed, covering part of the pupils, and slanting downwards towards the centre of the face. Jack's eyes don't always look like this, but it's fair to say it's a look that we identify him by.

Fig. 4

Comparing Fig. 1 with Fig. 3, I realized that by exaggerating the forehead and chin I had made the face look too thin, so I widened it. Unfortunately this meant that the nose was now a little on the small side so I made that larger and broader. Finally I added a little tone around the eyes, on the side of the face and under the nose and chin to make the caricature look more life-like and three-dimensional. Try this with one of your favourite movie stars, you may be pleasantly surprised how much visual information you have stored away in your memory.

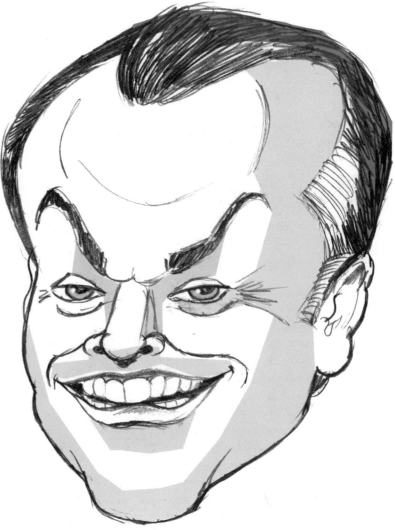

Drawing a full-face caricature

Although the three-quarter angle is usually favoured by caricaturists, drawing your subject full-face may have some advantages, depending on who it is and how their facial features are laid out.

Take this subject, for example – me. Despite seeing myself in the mirror every day for more years than I care to mention, until I contemplated drawing a full-face caricature of myself I never realized that my nose is quite as bent as it is.

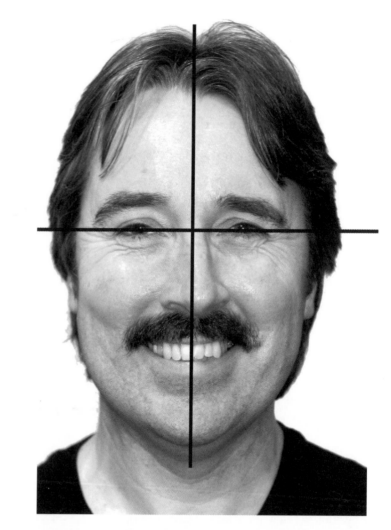

Drawing a vertical line down the centre of my face highlights just how off-centre my nose is. It's positioned to the left-hand side of my face, making my head appear to be turned slightly. In fact, it's positioned square on to the camera.

I have also drawn a horizontal line across my face at eye level. This shows that my left eye is slightly higher than my right.

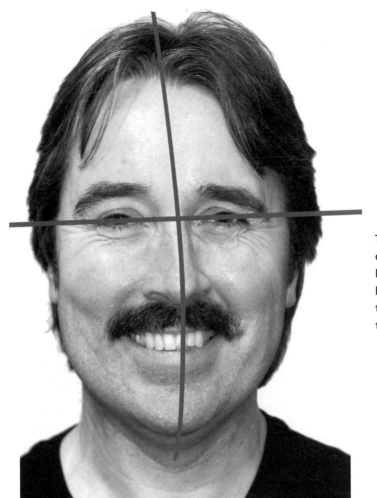

This time a vertical line drawn from the centre of the head to the chin follows the line of the nose, showing how it curves. A horizontal line through the centre of both the eyes rises to the right, illustrating that they are definitely at different levels.

Here the first set of lines is overlaid by the second set (in grey). There isn't a vast difference between these lines, but this is the attention to detail you need to look for.

After studying this photo for a while I realized just how asymmetrical my face is. Considering that the most beautiful people on the planet are renowned for the symmetry of their features, I fall short by a long way. My left eyebrow drops lower than the right and is less curved. Although my hair is parted roughly in the middle, the hair on the left hangs in a totally different manner to that of the right.

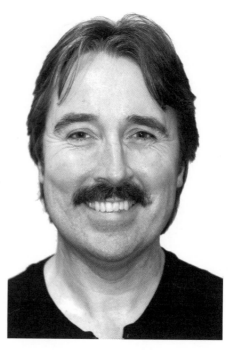

Once I was aware of all my unique facial imperfections it was time to transfer the information I had observed on to paper. This is a quick pencil sketch I drew first. I exaggerated the positioning of the horizontal and vertical lines slightly and used them as a reminder that my nose needs to bend to the left and my left eye is slightly higher up than my right.

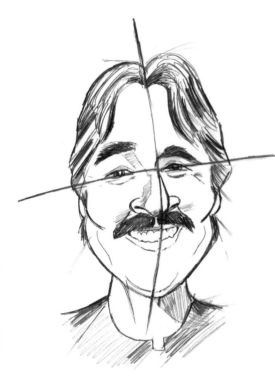

Still using a pencil, I worked the sketch up a little, adding heavier lines and some light shading. For learning purposes I have not erased the guidelines. At this stage the illustration has begun to come to life and look a bit less two-dimensional.

Note that the unique facial features have been exaggerated yet the face remains a good likeness of the original photograph on the facing page.

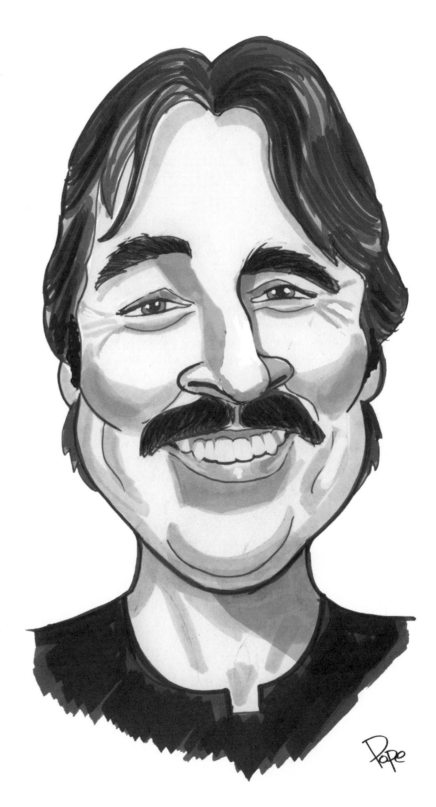

This is my finished illustration. It was traced from the one above on to a fresh piece of paper using a lightbox and pencil. I then drew over the outlines with a black brush pen. The finer lines were drawn with a black fineliner pen, while the hair, shirt and shading were rendered with marker pens in three different shades of grey.

The caricature is relatively tame. I didn't want to offend the model – he is very sensitive!

Drawing a caricature in profile

Drawing a caricature in profile is not so popular as it used to be. Once it was probably the most common angle; if you look back through vintage caricatures you will find many politicians and high-ranking military figures drawn in profile.

This is the subject I shall be caricaturing in profile. From the front, we can establish that he has quite a bulbous nose, but we can't see its full size from this angle. His right eye is slightly lower than his left but other than that there isn't much more information to be gained from this angle. This is definitely not the best angle to caricature this subject from.

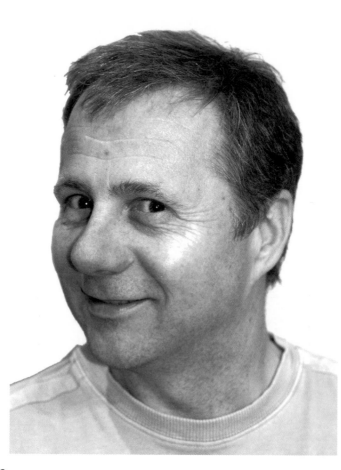

At a full-face view our subject's ears were hardly visible at all. However, from this three-quarter angle we can gain a lot more information. We can see his left ear in detail and can now get a better idea of the size of his nose.

Viewing our subject in profile, we get a clear outline of his forehead, nose, mouth and chin. It's now very apparent that our subject's nose is his most distinguishing feature. It's larger than average and also turns up.

Here I have placed the Face Base square with guidelines over the top of our photograph. I'm not suggesting that every time you draw a caricature from a photograph you do this; by all means use this system to start with to help you identify what is unique about your subject, but eventually you should notice these things naturally.

The tops of the eye and ear are quite close to the Face Base guidelines.

The nose juts well outside the square and turns up. The nostrils are large.

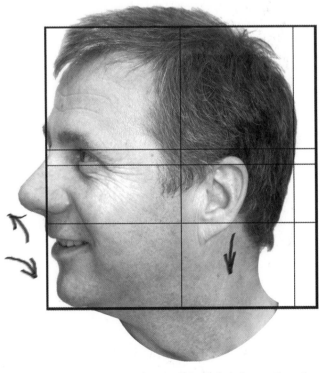

The bottom lip and chin fall back from the top lip.

The ear falls slightly lower than the guideline and the nose is a little higher.

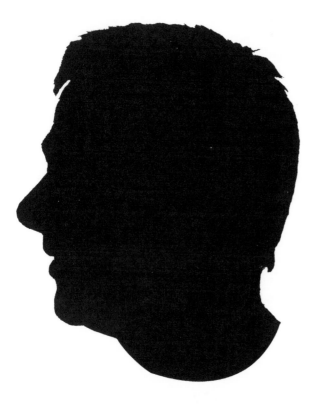
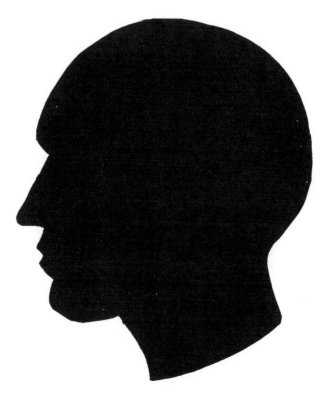

In silhouette images there is less to be distracted by. Take a look at the two above, one of our subject and one of the Face Base. Side by side you can see just how different their profiles are. You can also see that our subject's nose turns up considerably in comparison to that of the Face Base. What's interesting, though, is that it doesn't stick out nearly as much as you might have thought. This is because nearly half the width of his nose at the base is positioned far back on to his face – take a look at the photograph below.

A large part of the nostril is positioned far back on the face.

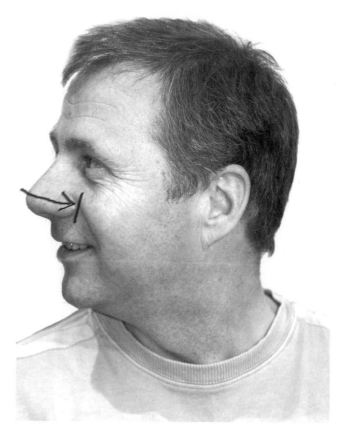

This is my pencil sketch. As you can see, I have slightly exaggerated the size of his nose and how much it turns up. I have also raised his smile and made more of the ridge from his eyebrow to his forehead.

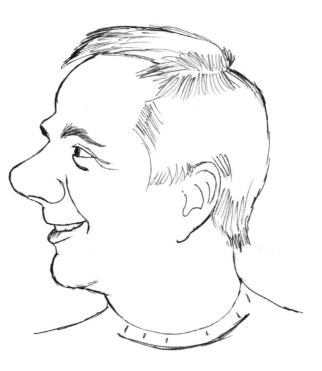

This is the same illustration with the outlines inked in and shading tones added with marker pens. I'm confident that the illustration resembles the photo, but it's not much of a caricature.

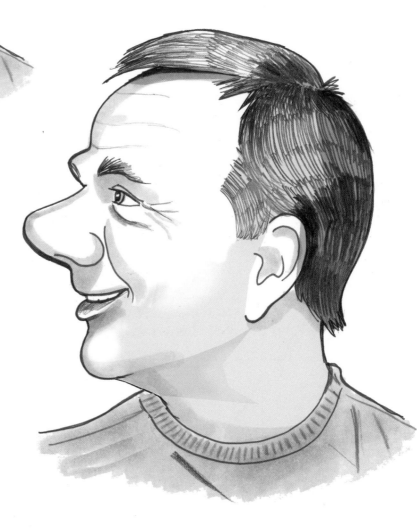

My final attempt. This time I have exaggerated my subject's nose a little more, added more flesh under his chin and more shading in that area. I also drew the hairline on the side of his head further back.

The three-quarter view

The three-quarter view is probably the caricaturist's favourite angle to work from as it's possible to get a better all-round feel of the subject's features and how they relate to one another in size and layout.

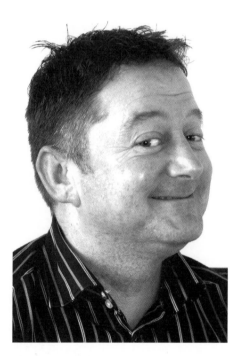

The three-quarter view – ideal to caricature someone from. It pays to also view your subject from both the front and side before you start your three-quarter drawing as you will gain different information from each angle.

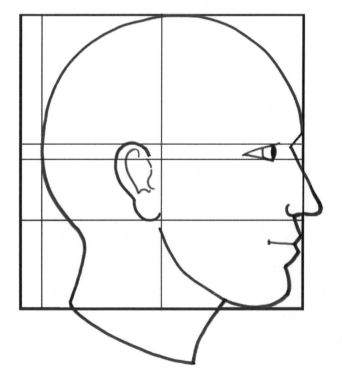

Take a look at this side view of the Face Base and compare it with our subject on the opposite page.

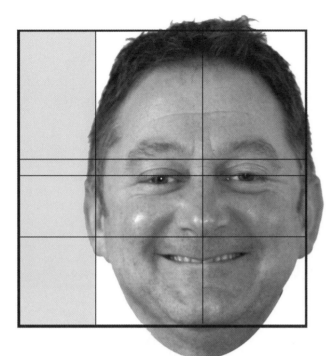
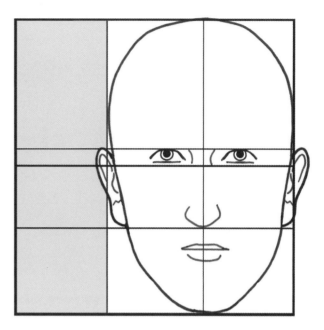

If we view our subject's face from the front and compare it with the Face Base, we can see his head is wider, taking up more of the square. The eyes are below the centre line and one is slightly higher than the other. The smile is wide and the cheek bones pronounced. We can tell the nose and chin are also pronounced, but from this angle we can't see by how much.

The ear is positioned very low compared to the Face Base.

Viewing the subject from the side, we can see exactly how far the nose, chin and forehead protrude.

The forehead slopes away toward the back.

The nose protrudes far out of the square.

The mouth and chin are also positioned outside the square.

The chin juts almost as far outside the square as the nose.

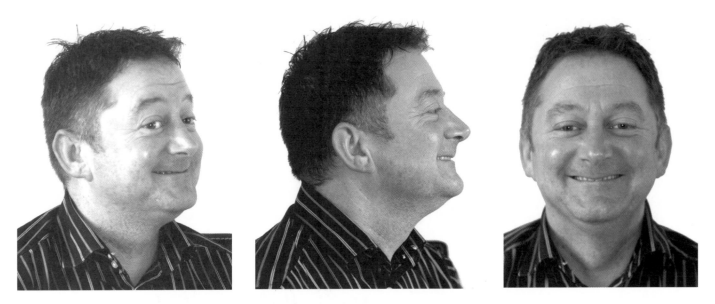

Now that we have gained information by studying the subject full face, in profile and from a three-quarter view, let's have an attempt at drawing him.

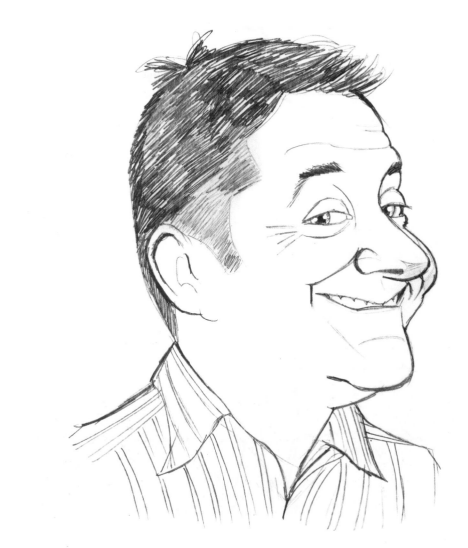

This was my first attempt. As you would expect, I exaggerated the nose and chin. I also emphasized the inward slope from the base of the nose to the top of the mouth and from the end of the chin to the bottom lip.

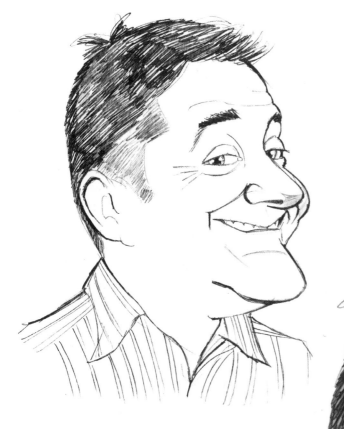

After drawing the first sketch I felt I had a resemblance, but it was obvious that the whole head needed to be wider. I also felt the chin and neck needed to drop down lower and jut out more.

After sloping the forehead back even further and increasing the width of the head a little more, I finished off by adding some tone. Note that even though the subject is smiling and showing his teeth, his lips meet in the middle. This for me was the most unique feature of the subject's face and well worth emphasizing.

Body proportions

As with the head, to be able to draw the body effectively you must have an understanding of its proportions. Over the next couple of pages I will cover this subject briefly, but I strongly recommend that you also buy a good book on human anatomy – it's a must for anyone serious about drawing the human figure.

Average male and female bodies are quite different from one another, so we will look at them individually.

This body is of an average adult male. He stands approximately 7½ heads high. Of course these proportions can vary considerably from one person to another, but as with the Face Base this is just a point of reference.

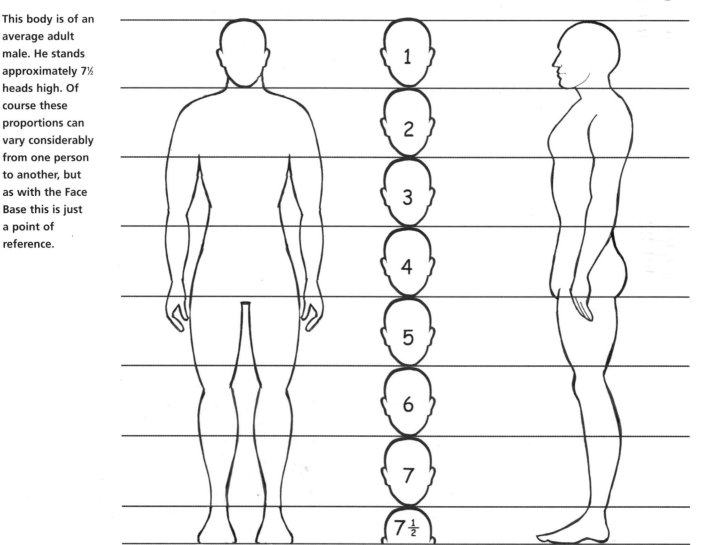

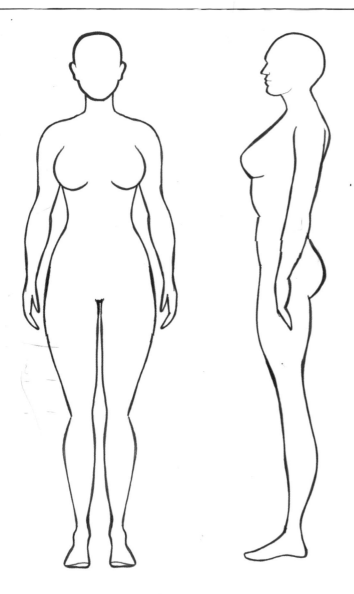

The average woman's body does not differ greatly from a man's in the proportion of head to height. However, the height is less, the hips are proportionately wider and the shoulders are less broad. With the addition of breasts and rounder buttocks, the female form is more curvaceous than the male's.

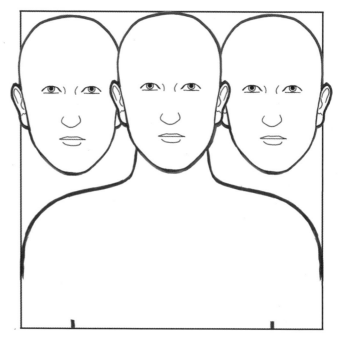

As a guide, the distance from the side of the head to the outside of the shoulder is approximately the same width as the head.

Another guide is to turn the head on its side. The distance from the centre of the head to the outside of the shoulder is approximately the same distance as the length of the head turned on its side. Bear in mind when drawing women that the width of the combined heads may be slightly wider than the shoulders.

As a professional caricaturist I'm often asked to draw people engaging in unusual activities. It would unrealistic for me to ask someone to pose every time I wanted to capture a certain position, or to find a photograph to use as reference, so most of my figure work has to be created from memory and imagination. The more guidelines you have to work from the easier it becomes.

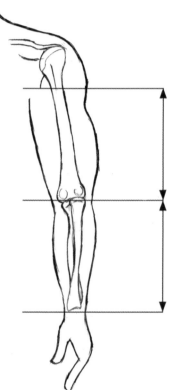

The distance between the armpit and the elbow is equal to the distance from the elbow to the wrist. Likewise, the distance from the the top of the inside leg to the knee is equal to the distance from the knee to the ankle. As people's proportions differ this will not always be the case, but these guidelines are safe to use.

Using the guidelines I have given so far, try drawing a figure in a certain position. At this stage don't worry about flesh, muscles or clothing – they can be added later. Draw your figure merely as a matchstick man, similar to this sketch.

This figure is around 6½ heads tall, not 7½, and if you were to check out the rest of its proportions you would probably find that they don't exactly match the guidelines I have listed. However, they are close enough.

Once you have an understanding of the human body's proportions, experiment by drawing simple figures involved in various activities, using simple lines for the limbs and small dots to highlight the joints. Drawing this way helps to pare down what you are trying to achieve. Although the sketches I created below have minimal detail and may not be 100 per cent accurate, it's still obvious what the figures are all doing. If you haven't got the proportions and movement right at this stage, why frustrate yourself by drawing them in more detail? This is great practice – let your imagination run wild and enjoy yourself.

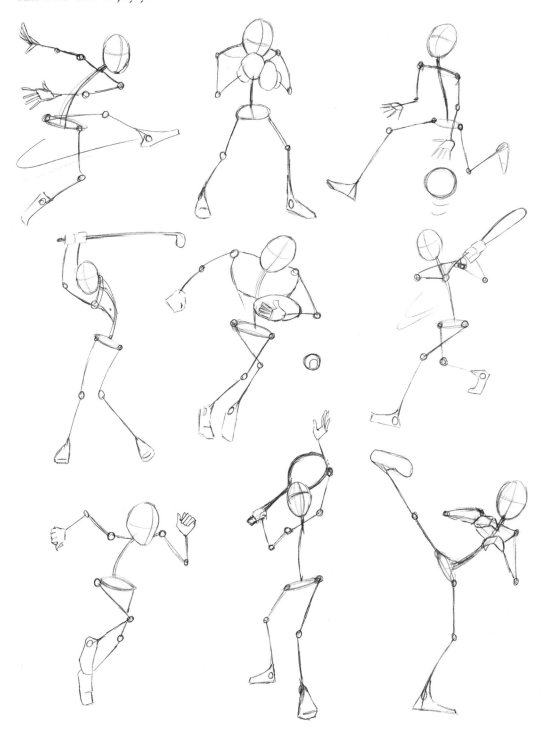

Caricaturing the body

In a caricature, the subject's body is usually much smaller in proportion to the head than in real life. One reason for this is that the caricaturist wants to draw attention to the subject's facial features and therefore uses as much space as possible to do this. The other is that diminishing the subject's body gives a humorous effect. However, as we are considering the body in this section I have drawn the heads at normal size.

The human form can be caricatured in just the same way as the head and face. Compare your subject to an average figure of the same gender and look for what makes him or her different.

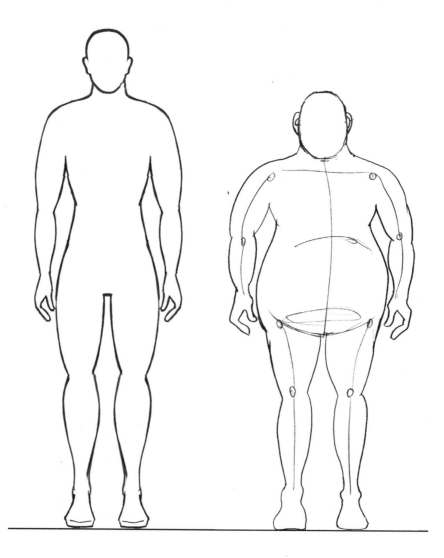

Our subject on the right is obviously a lot shorter and fatter than our Male Body Base (left). His head and neck are also considerably wider. He is not only fatter, his body is pear-shaped.

Using the information gained from our comparison, exaggerate the main differences you find. Take a look at the illustration far right. I have made our subject even shorter and more pear-shaped. His neck is so wide it almost disappears into his body.

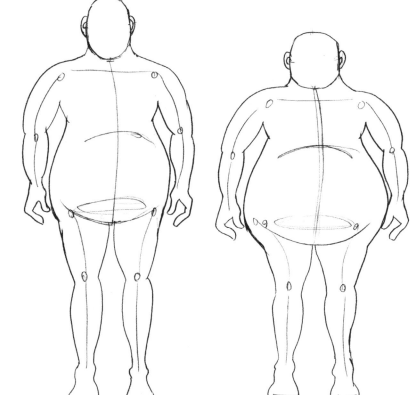

As with caricaturing the head, viewing your subject in profile allows you to gain extra information that you would not necessarily see from the front.

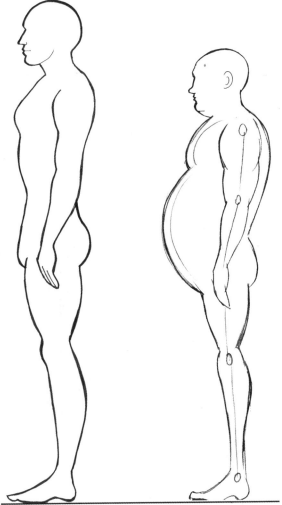

Although it's not so apparent how pear-shaped our subject is, from this angle (left) you can see just how much his stomach protrudes and how thin his legs are in relation to the rest of his body.

Following the same process as with the frontal view, exaggerate the main differences between our subject and the Male Body Base (far left).

I have re-created our subject on the right. He is shorter and his belly protrudes further still. His neck is wider and slightly shorter, and I have also added a little more flesh to his back to make him look more rotund.

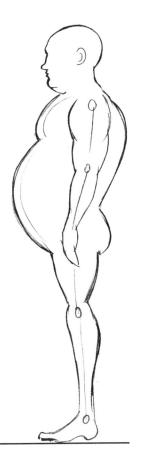

Caricaturing the female body

Here I show how to caricature the female form. It is generally more curvaceous than the male and there is consequently more scope for exaggeration.

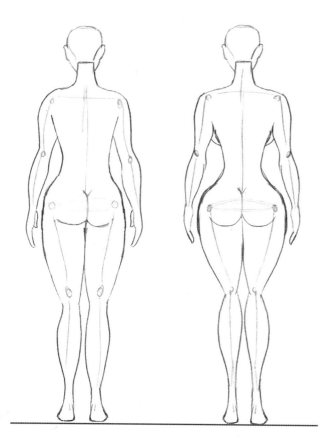

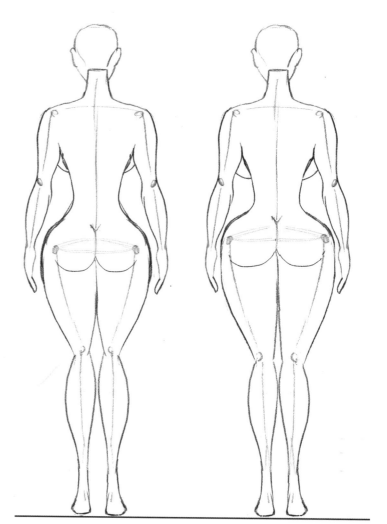

This time I have drawn my subject from behind. The illustration on the left is that of our Female Body Base. The figure to her right is an exaggerated representation of her form.

In the illustration to the right, I have exaggerated the female characteristics a step further. One of the main differences between the male and female form is that the female has wider hips in comparison to the waist, giving an hourglass effect. I have capitalized on this by taking it to the extreme. Viewed from behind, there is no doubt these two figures are female.

Viewing our subject from the front, you can still see the hourglass effect and now the breasts too – the most obvious feature that distinguishes the female form from the male.

In comparison to the Female Body Base (right) in the illustration far right the size and shape of the breasts have been exaggerated. The waist has also been made thinner to emphasize the hips.

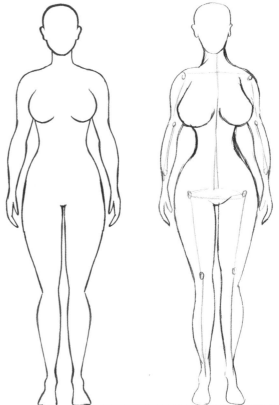

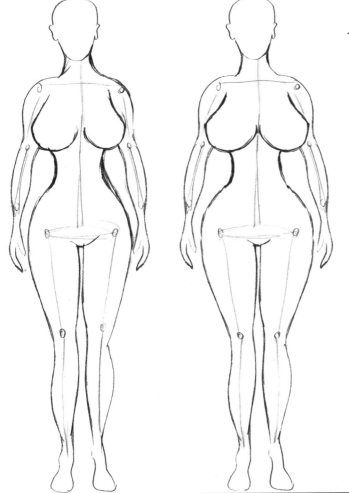

The illustration on the near left has been exaggerated a step further. I'm not suggesting you draw all women's bodies like this – it's a very stereotypical way of making sure the gender of the figure is identifiable, the same way as drawing a man with huge biceps and pectoral muscles and chiselled jaw would be.

Super heroines are often portrayed this way in comic book art – they are really just caricatures of the female form.

Body posture

By reading a person's body language we can gain an idea of their emotional state. To do that we need to look for three things: facial expression, gestures and posture. As with expressions, some people give away more information than others from their posture. However, in the same way that the face layout doesn't necessarily reflect how someone is feeling, the posture can be just the way they are made. For example, if someone has a downward-tilted head and slumped shoulders we may well think they are depressed, when the truth is that it's just their natural posture.

Whatever the reason for their posture, if it's unusual, the same rule applies when you are caricaturing: identify what it is, then exaggerate it.

This subject is not looking altogether happy. His head is angled downwards, looking toward the ground, and his shoulders are slumped. His arms are hanging lifelessly by his sides and his legs are bent at the knee.

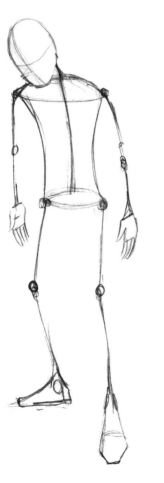

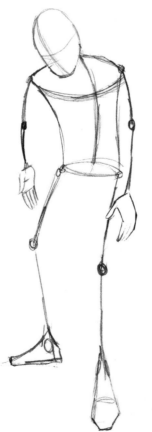

In this illustration I have emphasized our subject's posture slightly by slumping his shoulders more, bending his legs further and curving his spine to create more of a stoop. Overall, his posture looks even more negative than the original.

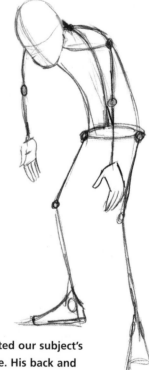

Here, I have exaggerated our subject's posture to the extreme. His back and knees are bent further, creating even more of a stooped posture. He now looks as if he has the whole world on his shoulders.

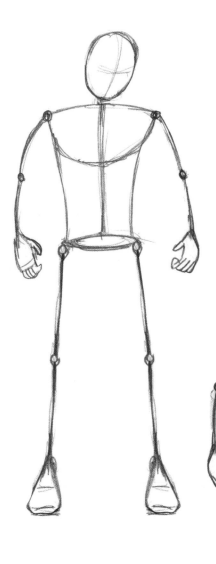

This figure's posture gives off a totally different message. He looks determined and maybe a little aggressive. His shoulders are positioned slightly back, forcing his chest out, and his arms arc slightly away from his body, creating the illusion that he is broader than in reality. Although his head is tilted downwards his eyes look straight ahead rather than down, indicating determination rather than negativity.

By throwing his shoulders back more and arcing the arms out wider I have made him look even bigger and more aggressive. I have also placed his feet further apart. Because his legs bend slightly his height has dropped a little, but overall he looks bigger and wider.

Exaggerating the body posture to the extreme, the same figure is now taking up as much room as possible and gives the appearance of being much bigger, more determined and a lot more aggressive than in the first illustration.

This female figure's posture is mildly sexual. Her head is tilted very slightly back and she is looking over her shoulder and to one side. The shoulder closest to us is lifted higher than the other because she has her left hand resting at the top of her hip. She is wearing high heels, which alters the natural body posture completely – her spine is arched backwards, forcing her chest forwards and upwards and her buttocks outwards.

This posture is a slight exaggeration of the one above. I have widened the distance between her feet and brought her left leg further over, exposing more of her buttocks and hips. Her back is more arched, which forces her chest out even further, and her head is also a little more tilted back than before.

In this very exaggerated version the buttocks are thrust backwards and the chest forwards. The head is rolled back, the left hand is perched outwards, away from the hip, and the left hand and arm are thrown further out away from the body. From a mild sexual pose this body posture has been caricatured to be almost an erotic dance.

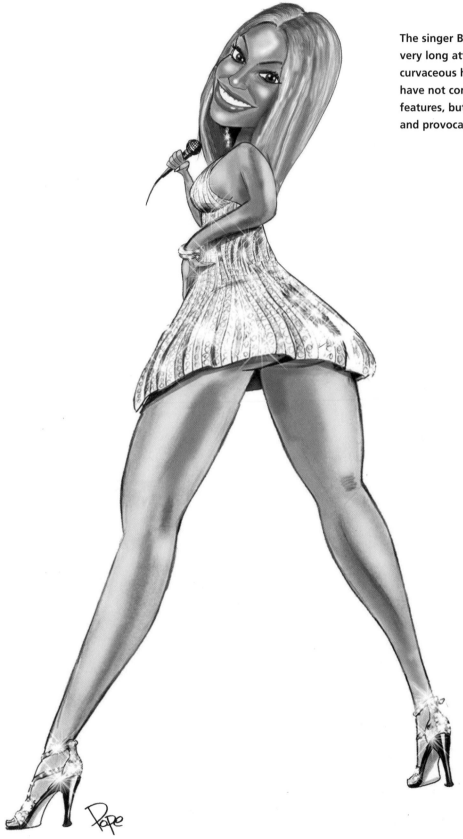

The singer Beyoncé Knowles has very long attractive legs with wide curvaceous hips. In this caricature I have not concentrated on her facial features, but on her female form and provocative body posture.

Gestures

Gestures, like body posture, can help us to identify how someone is feeling. The difference is that people are usually aware they are making them – they are a deliberate means of communication, most often through the use of the hands. Gestures are very visual and when employed correctly can be a powerful means of bringing your caricatures to life. They can also help to make them more humorous.

The illustrations on the next few pages are simple sketches that lack faces to illustrate how effective gestures can be using just a few lines.

Hold on, calm down.

Now let me think.

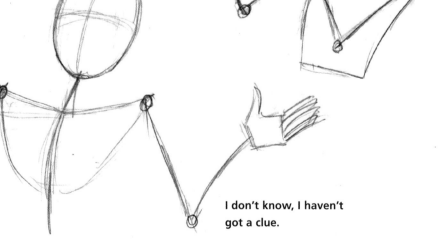

I don't know, I haven't got a clue.

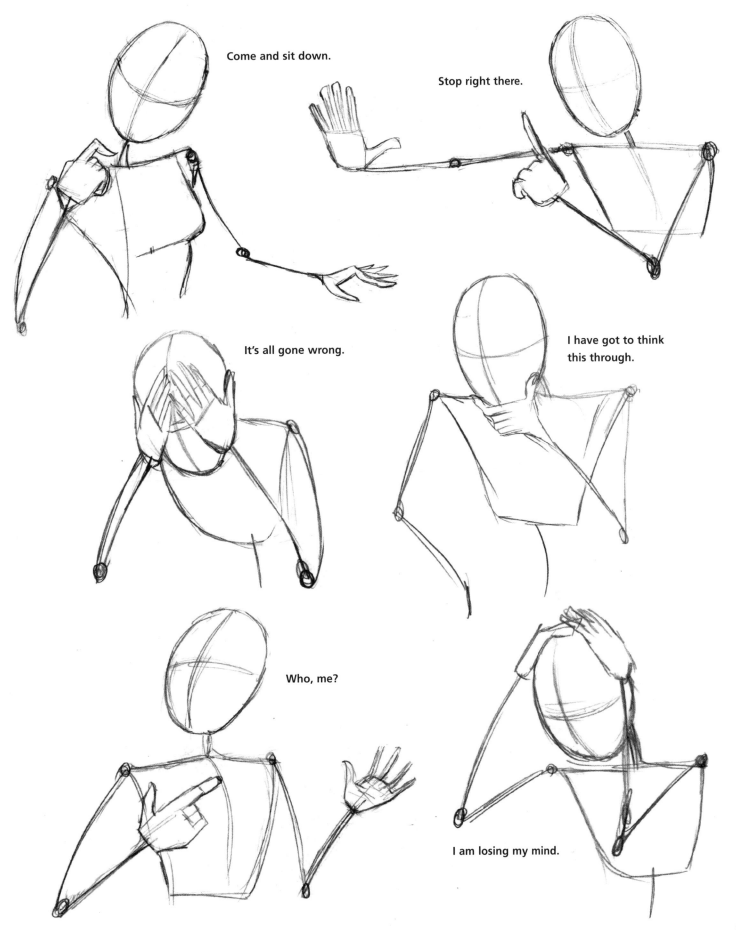

Come and sit down.

Stop right there.

It's all gone wrong.

I have got to think this through.

Who, me?

I am losing my mind.

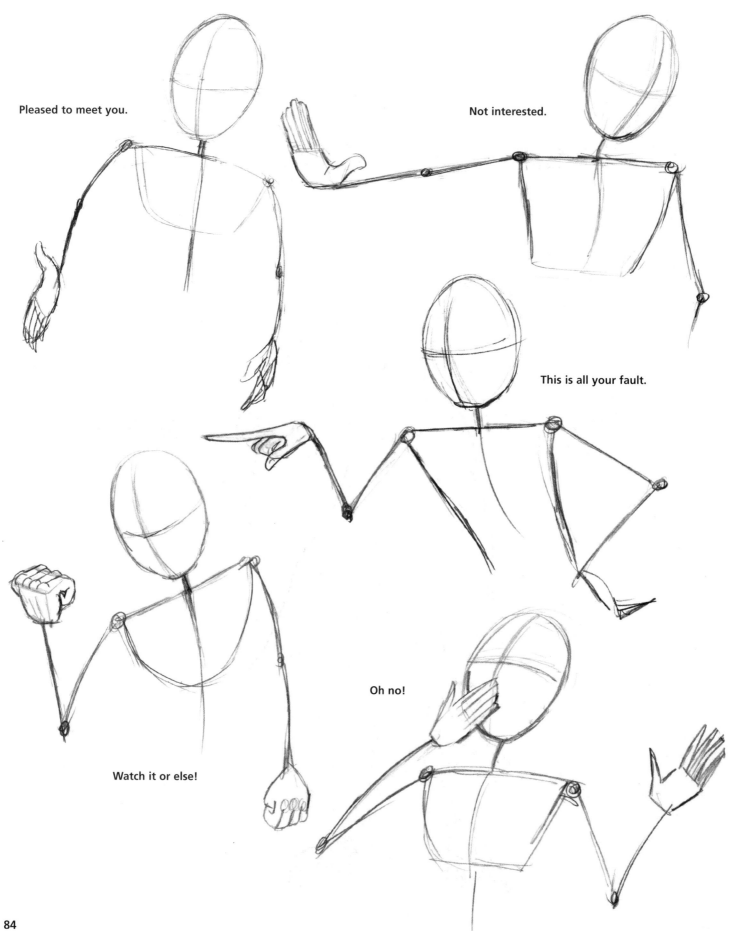

Pleased to meet you.

Not interested.

This is all your fault.

Oh no!

Watch it or else!

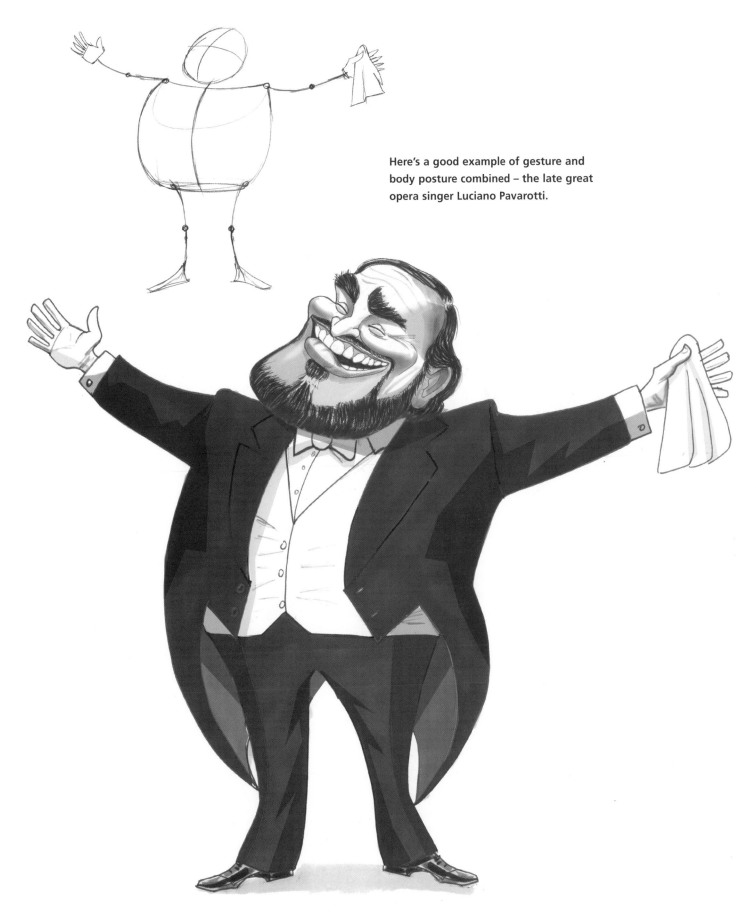

Here's a good example of gesture and body posture combined – the late great opera singer Luciano Pavarotti.

Props and clothing

As a caricaturist your aim should be to capture someone's likeness, discover what is unique about their face and exaggerate that uniqueness. If you have done your job properly it shouldn't matter what clothes your subject is wearing or what objects they are holding – they should still be recognizable. Don't fall into the trap of using props and labels as aids to identification every time you draw a caricature as this defeats the object you are trying to achieve. Once you are confident that people are recognizing your caricatures, by all means introduce props and characteristic clothing to enhance your handiwork.

To illustrate just how large a part props play in our recognition of well-known celebrities, I have removed the features on all the personalities drawn on these two pages. You should still be able to recognize who they are.

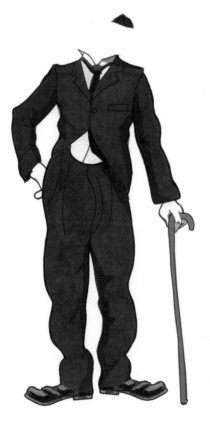

The facial hair and clothing alone should be enough to tell you who this comic icon is. If that's not enough, the unique stance and walking stick should leave you in no doubt that this is Charlie Chaplin.

Hairstyles and wigs come in all shapes, colours and sizes and, depending on how unusual they are, they may be one of the main features of your caricature. Likewise, spectacles may also be important, especially if they look like these. Who else could this be but Dame Edna?

The spectacles, moustache and thick eyebrows should be sufficient to identify this character. Even if you have never watched a Marx Brothers film, if you have ever been in a joke shop I'm sure you must have seen the plastic Groucho spectacles with fake nose, eyebrows and moustache attached. Groucho's characteristic walk and the cigar complete this faceless picture.

Melting clock, outrageous moustache, artist's palette and paintbrush. This must be Salvador Dali, the famous Spanish Surrealist painter.

If the lab coat, crazy white hair and moustache don't give it away, take a look at what's written on the blackboard. Of course, it's Albert Einstein.

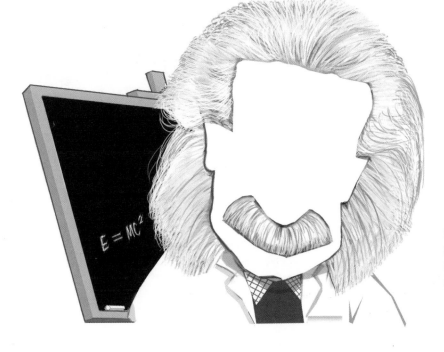

$E = MC^2$

Here are all the same personalities, but this time I have included their faces. Although I had these great props to use, I still made the effort to capture their character and unique facial features.

I particularly enjoyed creating this caricature of Barry Humphries' Dame Edna Everage. Even though I had the help of the outrageous spectacles and wig, I still wanted to capture that unique expression that Barry has perfected.

As historical figures, the facial expressions of Chaplin and Einstein are less well known. But the props and clothing put them in context and their faces are instantly recognizable.

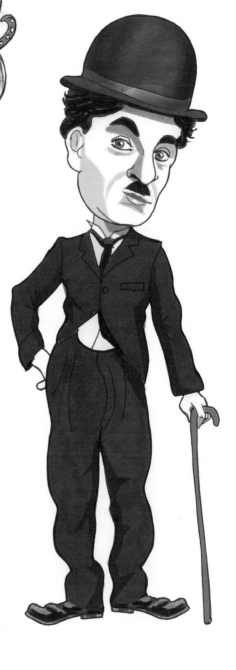

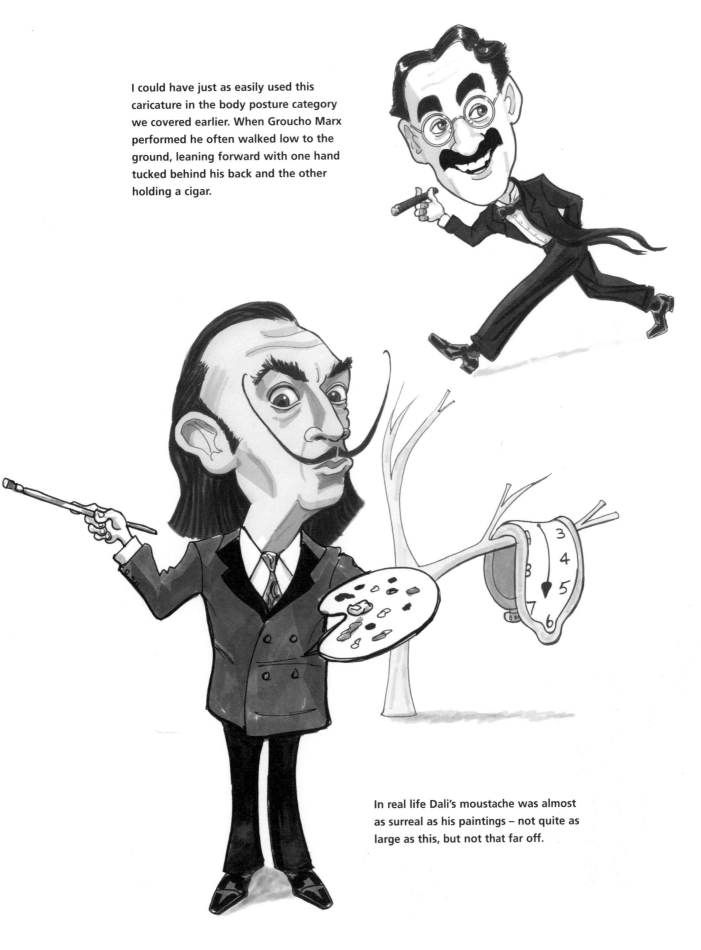

I could have just as easily used this caricature in the body posture category we covered earlier. When Groucho Marx performed he often walked low to the ground, leaning forward with one hand tucked behind his back and the other holding a cigar.

In real life Dali's moustache was almost as surreal as his paintings – not quite as large as this, but not that far off.

Combining props, posture and clothing

For this exercise I chose to caricature US politcian George W. Bush. Bush is invariably caricatured as either a cowboy wearing an oversized stetson or as a chimpanzee – the former because he lives in Texas and the latter because unfortunately for him he resembles one. His body posture also suits either description as he seems to arch his arms away from his body, which makes him look even more like an ape or a cowboy ready to draw in a gunfight.

I wanted to draw Bush behaving like a dominant male chimpanzee defending what he thought was his part of the jungle. This was a rough sketch to get a feel for what I was after.

The next step was to transform this image into human form. Although I wanted his body posture to remain as close to a chimpanzee's as possible I also wanted him to look human, with human limbs and proportions – apart from the oversized head, of course.

As far as clothing went I wanted him dressed as normal, in a suit and tie. I thought the suit jacket unbuttoned and the tie flapping in the wind would be a nice touch. In spite of the suit, I tried to keep the body posture as close as possible to a chimpanzee's, completely unafraid of heights.

The next stage was to establish what I was going to use as a suitable prop for my subject to be hanging from. I needed one that was relevant to his everyday life. What better than a flagpole with the American Stars and Stripes flapping in the wind as a backdrop?

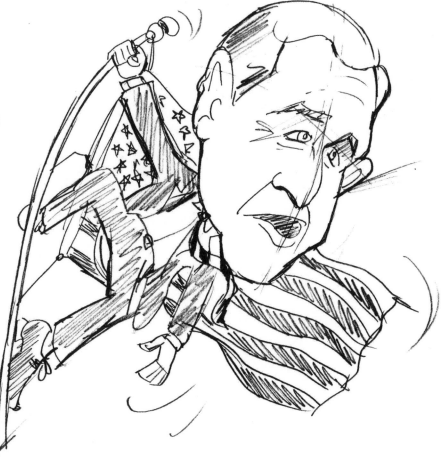

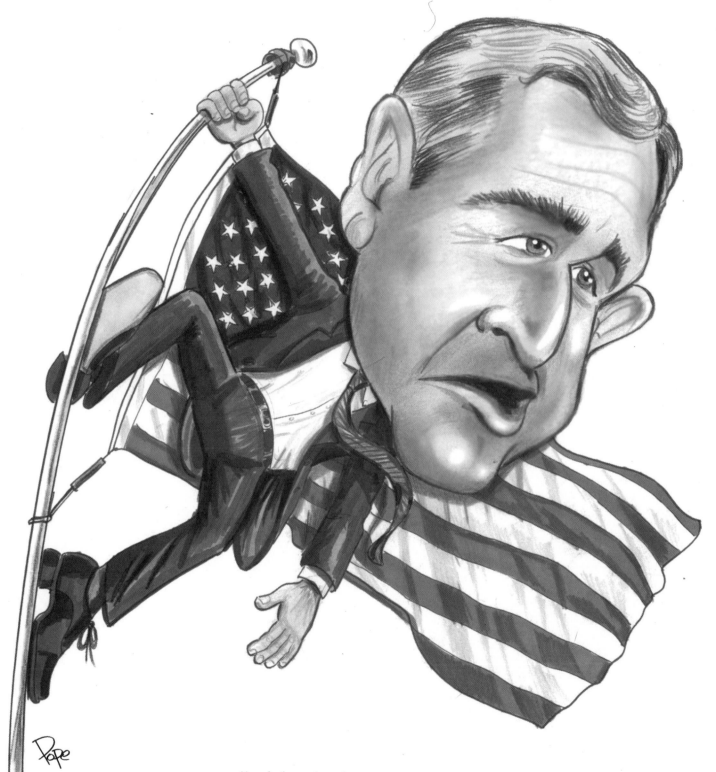

Here is the end result – George W. Bush hanging from a flagpole with the body posture of a chimpanzee. The addition of the American stars and stripes flag flapping in the breeze behind serves as a great backdrop and really helps finish this caricature off. This is a good example of how to use props and body posture effectively to enhance your caricature.

Below is another example of the use of posture and props – a caricature I created of the famous British football star David Beckham. His posture is that of a powerful athlete and his props are the football and the footballer's clothing.

Rightly or wrongly, people of power like politicians and some celebrities are often lampooned by caricaturists, but not all caricatures have to look this way. When it comes to drawing one that is intended as a gift you may wish to adopt a more sensitive approach. If not, the caricature you create may well end up in the waste bin instead of hanging on the wall.

Sometimes the aim is to produce a caricature that is fun, light-hearted and, if possible, flattering. David Beckham is renowned for his good looks as well as his football skills. In this caricature I chose to capitalize on those looks to make him even more striking. The artwork is still a caricature – his features are exaggerated, but unlike the George Bush caricature they are exaggerated less and in a flattering way.

Extreme exaggeration

The art of caricaturing is discovering which features to exaggerate, but by how much is down to personal preference. Some caricaturists exaggerate their subjects' features by a relatively small amount while others exaggerate to the extreme.

This is a caricature of the British singer-songwriter Amy Winehouse. In terms of caricaturing, someone like Amy is similar to Dame Edna – her unusually large hair extensions and false eyelashes could be classed as props and certainly make her stand out from the crowd. Her features and thin tattooed body are also easily identifiable.

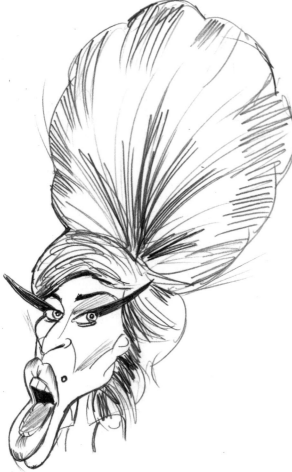

In this pencil sketch I took the three most prominent features from my original caricature, the hair, eyelashes and mouth, and increased their size. As you can see from the finished work below, not only is the resemblance to Amy still there, it could be argued that it's a better caricature than my original.

The more unusual your subject looks, the easier it is to maintain a good resemblance while exaggerating to the extreme.

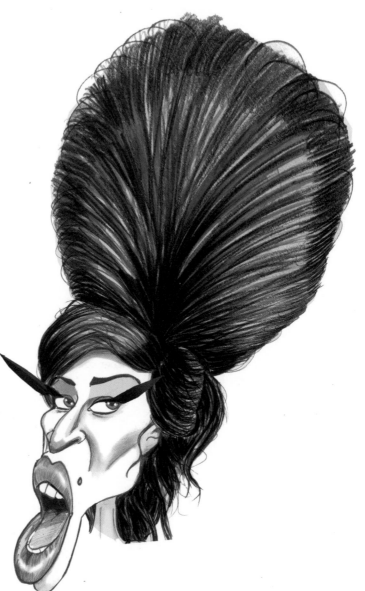

This time I've chosen a subject who has less in the way of hair and eye make-up to work with. However, her facial bone structure does have an amazing chiselled look and she has famously voluptuous lips.

Admittedly the body posture and outfit are a give-away, but the face alone should tell you that this is none other than the American movie star Angelina Jolie as the character Lara Croft from *Tomb Raider*.

As with my original caricature, in this pencil sketch I have identified the main features that make my subject unique. The high, pronounced cheekbones, the strong jaw line and large lips have all been exaggerated, only this time by a greater amount.

Here is the finished caricature, exaggerated to the extreme. She may not look as attractive as my original but there's no mistaking who she is.

A larger version of this Arnold Schwarzenegger caricature appeared on page 45, in the section on jaw lines. He certainly has a large, strong jaw line, which is why I chose to use him again as an example of extreme exaggeration.

He also has a number of other characteristic features to play with. In this pencil sketch I have not only increased the size of his chin and jaw – his mouth, eyebrows, nose, forehead, neck and the gap between his teeth have all been exaggerated further.

This is my finished, more extreme version of Arnie. When comparing the two, you could be forgiven for mistaking my original for a straight portrait. However, if you were to view it alongside one of the photographs I used for reference, you would be in no doubt that it is a caricature, just a less extreme version than this one.

Mick Jagger was an ideal subject to use for this extreme form of caricaturing. His features are so distinct and unique he almost looks like a caricature in real life.

Anthropomorphism

Strictly speaking, anthropomorphism means the attribution of human motivation, characteristics or behaviour to inanimate objects, animals, deities or natural phenomena. To a caricaturist, it means to draw animals or objects with human features.

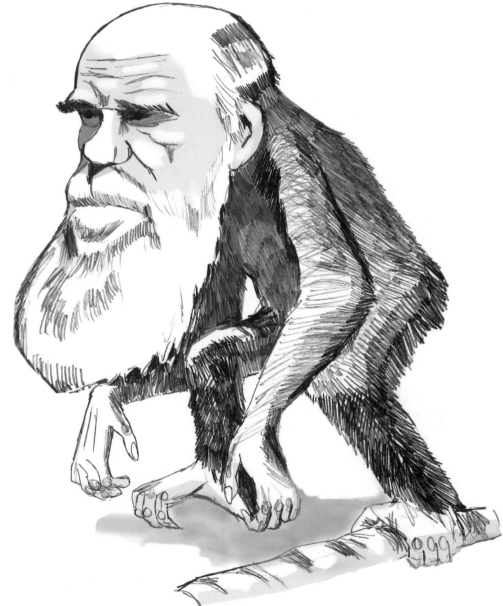

The illustration here is my interpretation of a famous caricature of Charles Darwin published in 1871. Darwin was drawn with the body of an ape in a satirical attempt to ridicule his radical theory of evolution.

The caricaturist who drew the original was clever in the way he portrayed the chimpanzee's body. Unlike Darwin, he obviously wanted to focus on the differences between a chimpanzee's body and that of a human rather than the similarities. How better to achieve that than to have Darwin's foot clasping a branch?

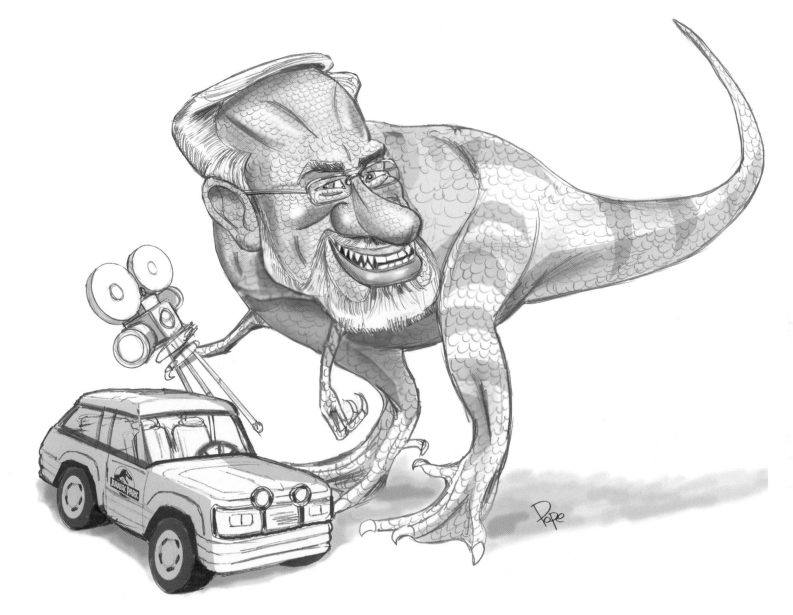

Here we have something a little more up to date – my own creation of the film director Steven Spielberg morphed into one of the prehistoric creatures from his movie *Jurassic Park*. This time, rather than just placing a human head on an animal's body, I have taken the anthropomorphism process a step further by merging the two subjects into one. Even though his skin has been replaced by scales and some of his teeth are non-human, the face is still recognizable as Spielberg.

The further you take anthropomorphism the more skilful you need to be. If I had made the subject's head look too much like a dinosaur he would have looked less like Spielberg, so it's a fine line as to where to stop.

When you are drawing this type of caricature the addition of props is worth considering. I have used two in this illustration; I added the SUV to give a scale of how big my subject is and I put a movie camera in his hand to help guide the viewer to the right theme.

A good way of testing if you've managed to produce a caricature that's really captured your subject's features is to remove the rest of the head – the hair, ears and jaw – then place what you have left within an animal or an object such as a tree. If it still resembles the subject you've achieved your goal.

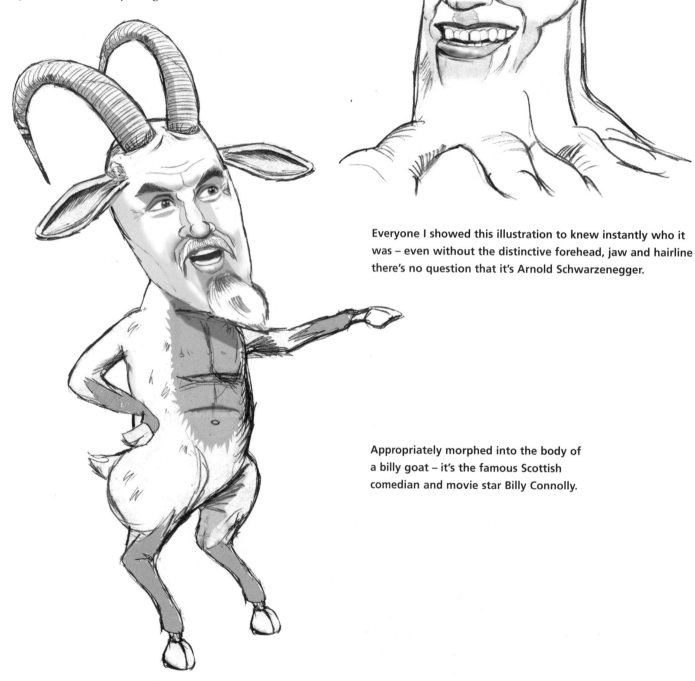

Everyone I showed this illustration to knew instantly who it was – even without the distinctive forehead, jaw and hairline there's no question that it's Arnold Schwarzenegger.

Appropriately morphed into the body of a billy goat – it's the famous Scottish comedian and movie star Billy Connolly.

This is a pencil sketch I drew from one of Gerald Scarfe's brilliant caricatures of Margaret Thatcher. It may be cruel and grotesque but in my opinion it's a masterpiece. Scarfe has the uncanny ability to draw the most hideous of creatures and yet with a few simple lines he manages to let us know who the politician is.

I believe Gerald Scarfe to be an absolute master of anthropomorphism and if this particular form of caricaturing interests you I strongly recommend that you check out his work.

Many of the top cartoonists who supply political cartoons to daily newspapers use anthropomorphism. One in particular is Steve Bell, who has a clever technique of using George Bush's features on various machines such as tanks and ships with great effect. The illustration here is my impression of one of Bell's cartoons, created in pen and ink. Like Gerald Scarfe, he uses minimal line work on the face but even though the subject is a tank we can still identify who it is – a very impressive use of anthropomorphism.

Tools and materials

There are no golden rules as to which tools or materials you should use for your caricatures; some caricaturists spend literally days working on their caricatures in incredible detail using oil paints, while others produce them with a brush pen in under five minutes. I believe it's healthy to experiment with all mediums and even mix them together if they give you the result you are looking for.

Needless to say, there's a vast range of tools and materials to choose from and to cover them in detail would take a book in itself. Here, I shall provide just an introduction to the basic tools and materials that I use and a brief guide on how to make the most of them.

The pencil is a good starting point. It's an ideal tool for sketching out preliminary ideas and drafts and can also be used to render a finely detailed piece of artwork.

Pencil leads come in different grades, ranging from 6H (the hardest) to 6B (the softest), with HB in the centre. I use an HB pencil most of the time when I'm sketching out ideas. With this grade, a minimum amount of pressure will produce a thin, faint line; if you want to add a heavier line or some dark shading, you can apply a little more pressure.

If you wish to render your finished caricature in pencil to give the effect of various skin tones it's worth using a selection of pencil grades. I use HB for the fine detailed work and the lighter shading and a soft 5B lead for the darker lines and shading. It's worth buying a pack of drawing pencils and experimenting to see the effects you can get from each one.

In general, use a good-quality soft eraser – a hard one may damage your paper.

A propelling pencil is another option. These come in different sizes to hold the various leads available. Their main advantage is that they never need to be sharpened.

Surfaces for a pencil caricature

There are various types of paper and card that can be used successfully with pencil. For sketching out ideas and drafts I use an A3 layout pad containing 80 sheets of 50gsm smooth, semi-transparent paper. This paper is ideal for drafting out your artwork as you can lay a fresh sheet over each drawing you make, working towards a more finished version every time.

With semi-transparent paper you can trace existing lines you're happy with from the previous drawings, then work up the drawing towards your final piece. You can also use felt markers on this paper.

Another option for drafting out ideas is to use any inexpensive A4 white copy paper, which can be bought in packs of 500 sheets. This is probably one of the cheapest ways of buying paper. However, as it isn't semi-transparent, you will need a light box in some form to trace any existing work.

At some point you will need to trace your draft work on to some thicker quality paper or card. A light box is a very useful piece of equipment, but I find that a large sheet of safety glass propped up in front of a desk lamp substitutes perfectly well for a large light box at a fraction of the cost.

For drawing my final artwork in pencil I mainly use A3 bristol board. It's not the cheapest surface available, but because of its thickness and extra-smooth surface it's suitable for most of the mediums I use. Pencil, pen and ink, felt tips, crayon, air brush, acrylics and watercolour washes can all be applied to this surface.

I particularly like this surface for pencil because it's smooth and allows you to blend the pencil strokes with your fingers to create an even tone.

I chose Sylvester Stallone as my subject on which to demonstrate the use of various mediums throughout the rest of this section.

This illustration was originally sketched out on layout paper, using an HB propelling pencil. It is just very basic line work, but enough to satisfy myself I had captured Stallone the way I wanted him. I then traced my drawing on to a sheet of bristol board.

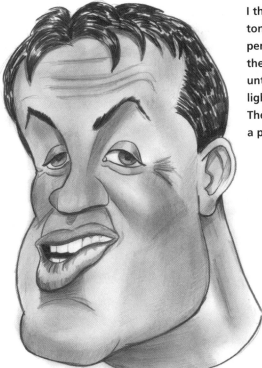

I then proceeded to render the skin tones using an HB pencil and a softer 5B pencil for the larger darker areas such as the hair and cheekbones. I left gaps untouched to give the impression of light reflecting off the hair and lips. There are various ways of shading with a pencil (see below).

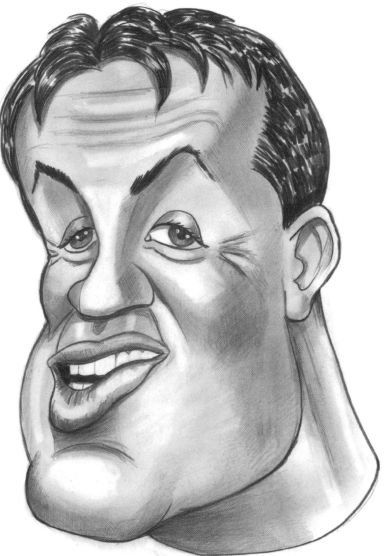

For light shading, draw faint lines close to each other. The closer they are, the darker the effect.

For heavier shading, use cross hatching – draw a set of lines running one way and another set across them.

To make a more even, blended tone like this, just rub your index finger lightly across your pencil shading.

To finish this pencil caricature, I used an eraser to create the highlighted areas on the skin such as the bridge of the nose, the tops of the cheekbones and the centre of the chin. I added some white designers' gouache to the eyes to make the small highlights. To protect my finished artwork from smudging, I sprayed it with some artist's transparent fixative for pastel, charcoal and pencil.

Markers and brush pens

Markers and brush pens are often used for caricaturing from life, mainly because they are so versatile and the ink dries fast, eliminating the likelihood of smudging. You can buy them with nibs of various sizes and shapes, from fine-liners to broad markers.

The brush-tipped pen is very popular with caricaturists. It flows gracefully across the paper and with a little practice you can determine the line thickness by the angle you hold it at and how much pressure you apply.

Markers are suitable for drawing, filling in blocks of colour and shading. You can buy these single-tipped or dual-tipped. The latter are very useful since they serve as two different pens, with one end pointed and the other flat, reducing the number of pens you have cluttering up your work area. You can also be confident that the colour and tone will remain constant as both nibs are being fed from the same ink reservoir. Another bonus of markers is that most of them can be refilled from ink bottles bought separately.

Fine-liner pens are generally used for detailed, intricate work such as eyelashes. You can buy these in various thicknesses; I use anything from 0.2 mm to 0.5mm. Like brush pens, they cannot be refilled.

Paper

You can buy special marker paper which is very thin and has a coating on the back to prevent the ink bleeding through. You could use ordinary copy paper, but this tends to absorb a lot more ink so the tones will appear darker and irregular. The ink may also bleed through to the other side.

I traced my original pencil sketch of Sylvester Stallone on to some bristol board, using a black brush pen. For the more intricate lines around the eyes and lips I used a 0.4mm fine-liner pen.

I drew the hair with three brush pens – one black and two different shades of grey. For the large areas of skin tone I used a light grey marker. For the darker shading around the jaw, inside the ear and beneath the chin I used one of the grey brush pens, which also served for shading the lips and eyes. The eyebrows, eyelashes and teeth were drawn in with a black fine-liner. Finally, I added some white designers' gouache to highlight the eyes and lips.

Drawing pens

A Gillott drawing pen and black Indian ink was once the most popular medium for caricaturists, despite the necessity to dip the pen repeatedly in the bottle of ink and the risk of catching the nib in the paper and splattering the artwork with ink blots. This method is still used by some of the top caricaturists, perhaps because some of them come from an older generation and grew up using these pens. Alternatively, it may be that they have mastered the art of working with something that is quite awkward to handle and has an authentic scratchy look that no other medium offers. Whatever the reason, I hope there will always be caricaturists willing to carry on using these pens and keeping this art form alive.

You can buy one of these pens with a set of nibs at quite a low price and I certainly recommend having a go.

Indian ink is very dark and dense. Using it can be a little frustrating as it takes a long time to dry, so you have to be careful not to smudge the lines you drew earlier as your caricature progresses. The advantage is that once it has dried it's waterproof, so if you wish to add some tone or colour you can do so with watercolour or coloured inks.

There are other drawing inks available on the market, so it's worth experimenting to see if you find a type that suits the way you work better than Indian ink.

A fine paintbrush will come in handy to fill in any large areas of black.

A medium-sized brush can be used to add some tone if required.

This illustration has been drawn on bristol board using a Gillott drawing pen and black Indian ink. As you can see, it's possible to achieve very fine or thick lines with this pen. With practice you'll soon discover how the pressure you apply and the angle you hold the pen to the paper control the flow of ink and the line thickness.

Cross hatching is very often used as a means of shading with this medium. Some of the hair was painted in with a fine paintbrush.

Once the Indian ink had dried I applied a light wash of colour with watercolour paints. Coloured inks would have given a similar effect, but watercolour is more flexible for mixing colour and also cheaper than inks. For the small highlights in the eyes I added some white designers' gouache.

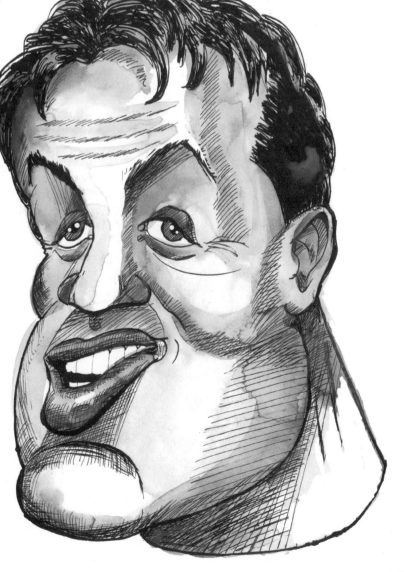

Mixing mediums

I'm all in favour of mixing various mediums to get the effect I want; when I produce colour caricatures for publication or for novelty gifts I use all of the tools and materials below. Over the next two pages I shall guide you through each stage to the final version of the Stallone caricature. Although you cannot see the colour here you should be able to see the variations in tones and texture, and you can take a look at the finished colour version on the back cover of this book.

Faber-Castell Polychromos Artists' Pencils have a soft and water-resistant oil pastel lead that produces a rich stroke that cannot be smudged.

Water-soluble artists' painting crayons are ideal for blending together to create realistic skin tones.

A pencil with an eraser makes a useful tool for erasing colour from intricate areas of the face to create highlights. A softer eraser will only smear the water-soluble painting crayons.

Brush pens and markers are ideal for clothing and hair.

I use a fine-liner pen for fine strands of hair, eyelashes, or anything dark and intricate.

Applied with a fine brush, I use white designers' gouache for intricate highlighting on nearly all my artwork. Unlike other white paint it remains bright and strong and dries quite quickly.

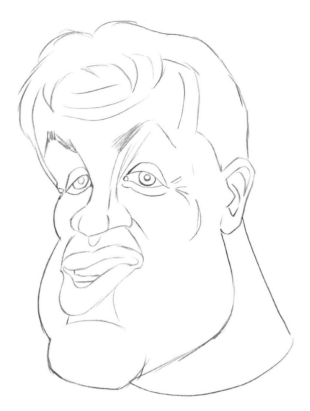

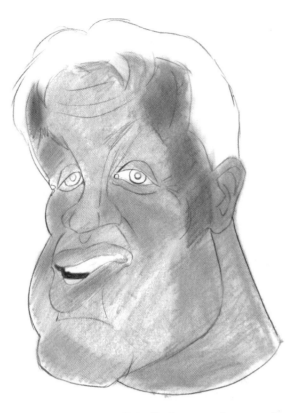

Using a terracotta Polychromos coloured pencil, I traced my original pencil drawing on to a sheet of bristol board. Terracotta is an ideal colour for this as it's dark enough to show through lighter skin tones and doesn't look out of place against them.

The next stage was to add a light flesh tone, using one of my water-soluble artists' painting crayons. I shaded lightly all over, then blended it with my fingers. Once I had a light skin tone over the whole face I could begin to introduce deeper-coloured skin tones in the appropriate places, blending in the various colours as I worked. At this point the artwork often looks a little messy, but it's only a form of undercoat.

Now it was time to use the Polychromos coloured pencils again, drawing over my original lines that were now slightly covered over by the water-soluble painting crayons. This brought definition back to my caricature.

Choosing the relevant colours, I added intricate line work to the skin such as bags and crows' feet around the eyes. I used dark brown and black for the eyebrows and various shades of flesh and red for the lips. For the eyes, I used a marker and a fine-liner pen.

For the hair I used a combination of brush pens, Polychromos coloured pencils and a black fine-liner pen. I blocked in the inside of the mouth with a brush pen and a fine-liner pen.

All the caricature needed now was a few tweaks to bring it to life. I used the eraser on the end of a pencil to create the highlights on the skin and white designers' gouache to highlight the eyes and lips. Finally, I added more definition here and there with Polychromos coloured pencils.

As with most skills, you will need to practise before you can produce effective drawings. However, all of the materials used to create this caricature are practical and relatively easy to use.

Caricaturing from life

There's a huge difference between drawing from life and drawing from a photograph. While you can study a photograph at leisure, a live subject can shift position, change expression, become nervous or impatient and so on. When you draw from life, especially if you are being paid for it, you need to draw at a faster pace and be more decisive with the lines you draw. Before you begin, spend a minute just looking at your subject, thinking about how you are going to approach the caricature and which of their features you are going to exaggerate. To start with, you can use a pencil or a light grey brush pen to work out a rough framework, but aim to do away with this process eventually: in general the lines you put down stay down.

When you draw from life you need to learn not to be too much of a perfectionist, otherwise you will never relax enough to be able to improve. Taking great pride in getting the best likeness you can is fine if you are keen to get into the world of published caricatures, but if you want to draw from life you have to accept that some of your work will turn out well below the standard you want. However, as a very talented live caricaturist once pointed out to me, the person whom you are drawing is unlikely to possess any caricaturing talent at all and will probably be impressed by whatever you present them with, so try to relax and let the drawing flow.

Before I started my caricature from life I took this photograph of my model from the angle I decided to draw her from so that you have something to compare the finished artwork with. Note that it's from the preferred three-quarter angle.

When I first started drawing caricatures from life I chose people I knew personally. They would often comment on how serious I looked and how I frowned continually. This is not the best way to put your model at ease, so make sure you smile and try to make jovial conversation. This will relax your model and hopefully tempt a smile out of them.

Using a black brush pen, I started at the top of the head and worked down, laying out the contours of the face. Some caricaturists prefer to start with the eyes, nose and mouth, although the trouble with this method is that you can find yourself running out of space.

The next stage of my caricature was to draw the eyes, nose and overall shape of the mouth. People don't smile for long, so it's important to get the basic shape down as soon as you can.

Next I drew the lips, being careful not to apply too much pressure to my brush pen as I needed to keep the lines relatively thin. I then drew in the teeth using a fine-liner pen.

The next stage was to introduce some shading on the lips, cheekbones, eyes and hair. For this I used two more brush pens, a light and medium grey.

Using the black brush pen, I blocked in the top my model was wearing. I also added more overall tone to the flesh, hair and eyes, using all three brush pens. I was careful not to over-use the tone and lose the effect of light reflecting off the face and hair. At this point my caricature was starting to come to life and look more three-dimensional.

This is the finished caricature. I used a little more tone and added some eyelashes with a fine-liner pen. I also used a Tipp-Ex pen to add some highlights to the eyes, lips and hair and touch up the teeth. It's not the best caricature I've drawn, but it only took about six minutes. Therefore I'm reasonably happy with it – and luckily so was the model.

Computer technology

While I'm a strong believer in using traditional methods to create my artwork, I also welcome new technology with open arms. If there's a way of saving myself time and space then I am interested! There are many ways in which new technology can be of use to you as a caricaturist. Because this subject is so diverse and there are so many different types of software programs available I can only skim the surface here, but I hope to give you an insight into the paths you could take.

After a computer and the relevant software, the next thing on your list should be a scanner – preferably one that scans up to A3 size. Most A3 scanners are very expensive compared to A4 scanners. However, if you shop around you will find some on the market at roughly twice the price of a decent-quality A4 scanner and it's worth paying the extra money so you can scan larger caricatures.

Ideally you should buy a graphics tablet. You can get away with using a mouse to control the tools and functions but a tablet is much more versatile and well worth owning.

As a rule I scan every piece of art I create in my studio and save it. This way I keep a record of everything I have produced so that if a client wants to talk about something I produced for them years ago I have it on file. I also use my own work as reference material for any similar projects that may come up.

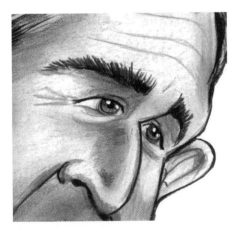

Apart from the basic storing of artwork, there are a number of other functions I use my computer for. If my artwork is to be used for publication, I will very often touch up the existing artwork in Photoshop. The flesh tones of the artwork shown left have coarse lines from the original pencil and crayon rendering. The same image below has had the coarse lines softened by using the blend option and highlights added to the forehead, nose and cheeks with the Paintbrush tool. The whites of the eyes have also been tidied up with Paintbrush.

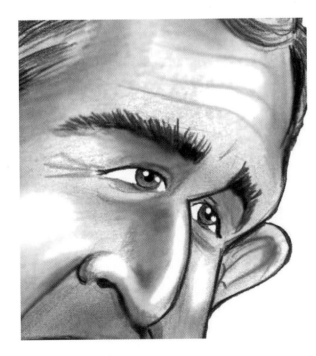

The icon shaped like a raindrop in the Photoshop toolbar is the blend option.

Here the paintbrush tool is highlighted. There are various choices of paintbrush available. For this purpose I chose the spray can.

Layers

The Layers function is most probably the most useful of all as it allows you to compose and manipulate each piece of artwork separately. This is particularly handy when you are producing large group caricatures. Before this type of software was available a caricaturist would either have to draw his or her artwork on huge pieces of paper or draw the subjects so small that their faces would lack detail and definition.

To illustrate how you can benefit from using the Layers function I have chosen a number of caricatures used earlier in this book and created the large, somewhat unusual group caricature shown opposite.

First open one of the images you wish to incorporate into your group, then select the magic wand function from the toolbar. Click in an open area away from the main image and the outside of your image will become encompassed by a shimmering dotted line. You will need to select the 'inverse' function from the top toolbar so that you capture just the image and not the outside frame as well. Once you've done this, select Copy and you're ready to paste your image on to a new background.

Tolerance: 60

If the dotted line breaks into your artwork you can adjust the tolerance setting in the toolbar to suit.

Go through the magic wand process with each image you wish to introduce and paste them on to the same background. Each time they will be identified as a new layer (left). Click to the right of the layer box you wish to work on and it will be highlighted. You can then choose whether you want the layer to be in front of or behind the other layers.

You can also alter the size, shape, colour, brightness and contrast of each layer individually.

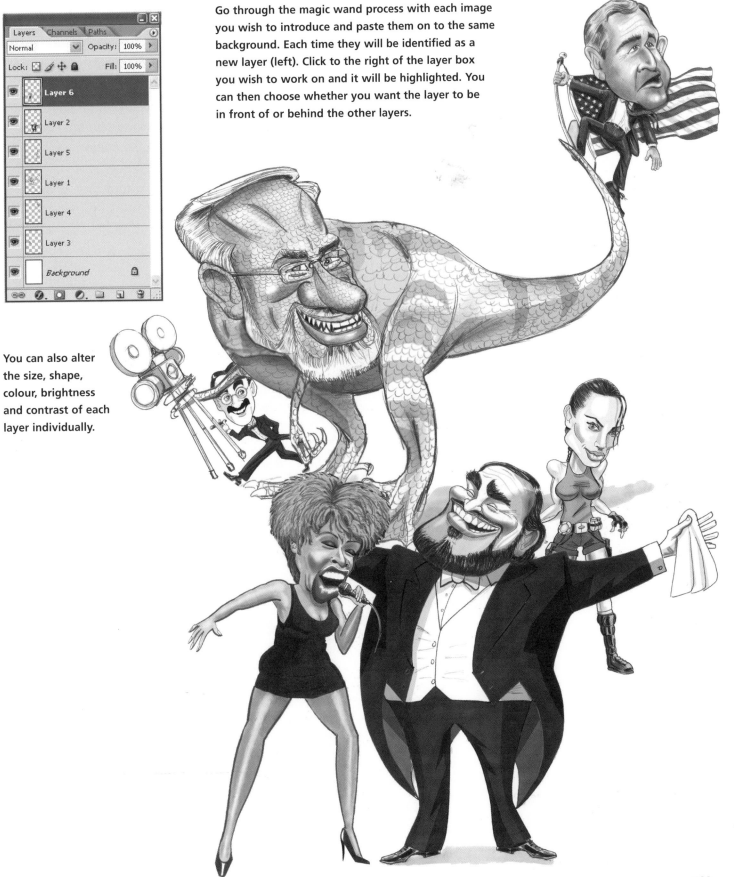

Manipulation of images

Another very useful function is the lasso tool, highlighted in the toolbar to the left of the image below. Using this tool, you can select any section of your artwork and treat it as a separate image, distorting its shape and size to suit your purposes with the relevant tools and functions. Once you have finished this process you can then paste the section down and save it once again as a complete image.

To demonstrate this exercise I have chosen to manipulate Spielbergerex's tail from the image below.

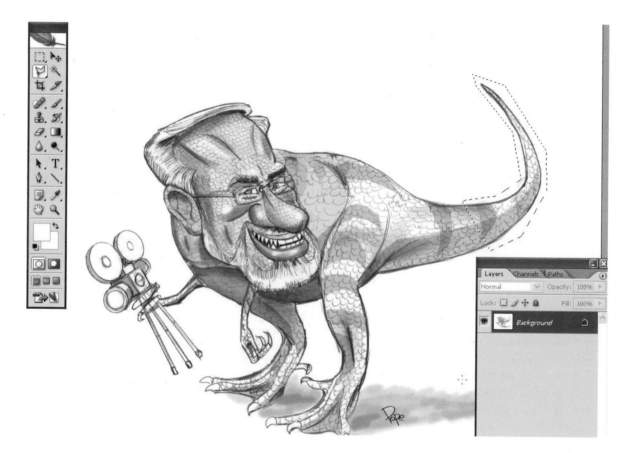

First choose the lasso tool, then click at various points around the area you wish to manipulate with your mouse or tablet pen. Finish by clicking at the same point you started to complete the shape, which will then be encompassed as before by a shimmering dotted line. Copy then paste and you will have a new layer to play with, in this case a new tail.

Once you have pasted down the layer, choose edit, transform and distort in that order as illustrated above. You will then be able to distort the layer's shape and size by clicking on any of the small squared drag points and dragging in the direction you want to go. The image shown right illustrates how, by dragging the top left corner of the layer, I have managed to change the length and angle of the tail.

Once you are happy with the size, shape and position of your layer, you will then need to flatten it on to the existing artwork by choosing the flatten image option as illustrated above. You can then erase the original image – in this case the original tail – by either using the eraser tool or the paintbrush tool in the relevant colour.

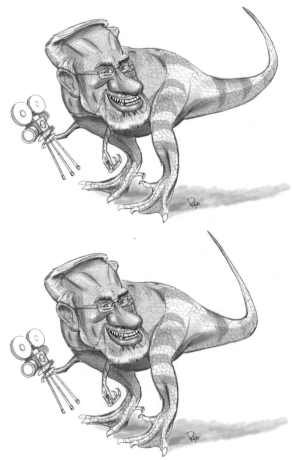

The image to the left is the original; shown below it is the one that's been manipulated. Notice how the tail turns up at more of an acute angle and only has one stripe.

By following this procedure you can alter more or less anything. It's very useful if there's something niggling about your artwork that you wish you had drawn differently.

Here's an example of how useful computer technology can be. Shown right is the caricature of Pavarotti that appeared earlier in the book (page 85). Like most caricaturists, I tend to draw heads on the large side. However, looking at this artwork later, I realized I had made a mistake – Pavarotti was famous for his enormous frame, so he should have one.

Using the same techniques as with my Spielbergerex, I reduced the head and hand size and made the body wider. I could have redrawn the whole thing again, but saved myself a lot of time by using the tools that are available to me.

Index

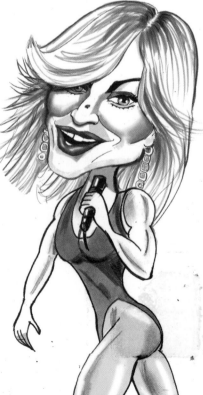